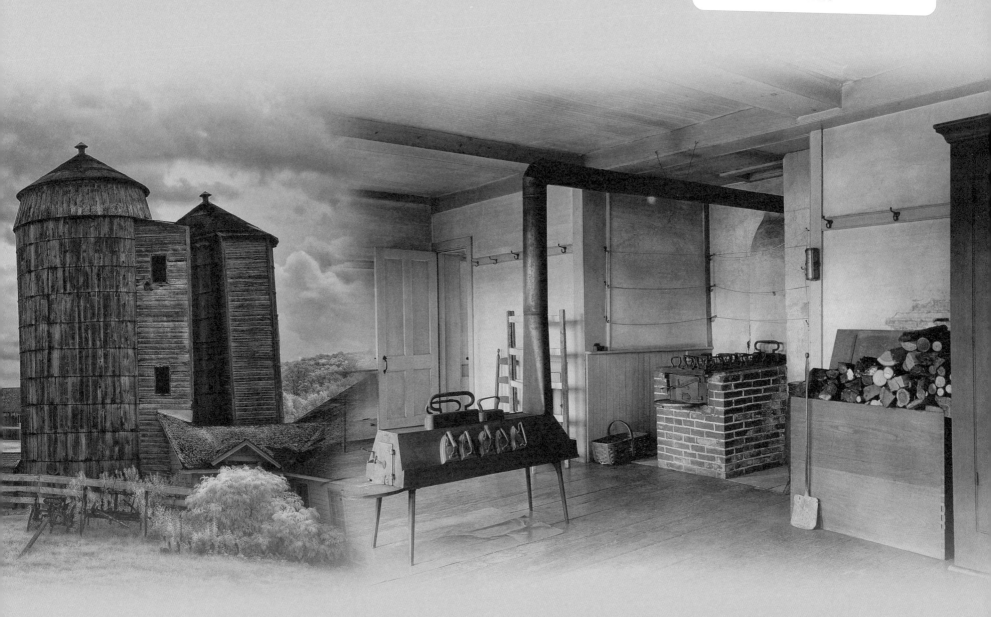

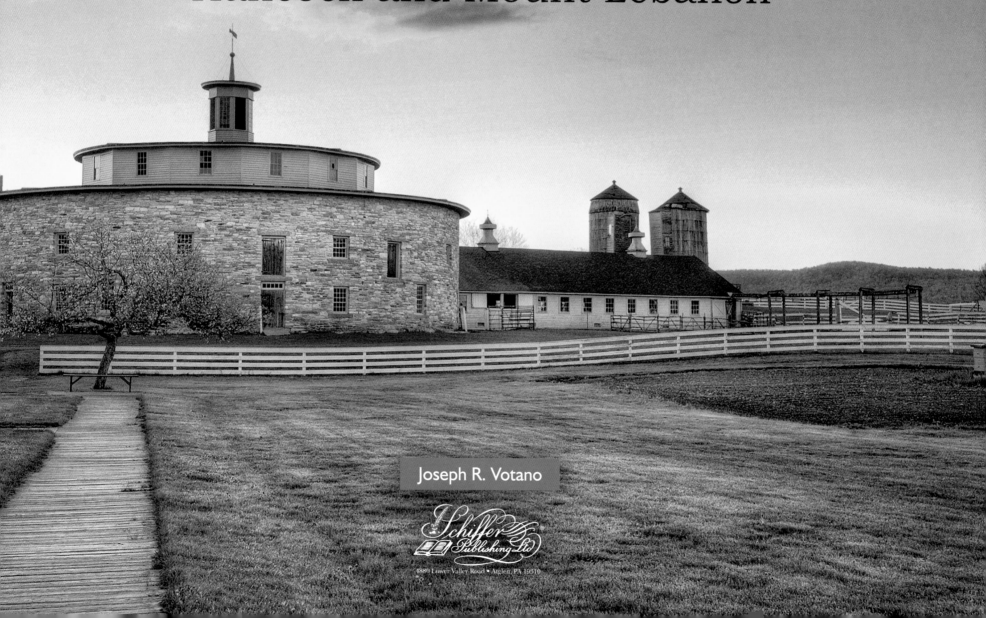

THE
SHAKER LEGACIES
Hancock and Mount Lebanon

Joseph R. Votano

Schiffer Publishing Ltd

1880 Lower Valley Road • Atglen, PA 19310

Designed by Danielle D. Farmer
Cover Design by Brenda McCallum
Type set in Bookman Old Style/Humanst521 BT

ISBN: 978-0-7643-4933-1

Printed in China

Published by Schiffer Publishing, Ltd.
4880 Lower Valley Road
Atglen, PA 19310
Phone: (610) 593-1777; Fax: (610) 593-2002
E-mail: Info@schifferbooks.com

For our complete selection of fine books on this and related subjects, please visit our website at www.schifferbooks.com. You may also write for a free catalog.

This book may be purchased from the publisher. Please try your bookstore first.

We are always looking for people to write books on new and related subjects. If you have an idea for a book, please contact us at proposals@schifferbooks.com.

Schiffer Publishing's titles are available at special discounts for bulk purchases for sales promotions or premiums. Special editions, including personalized covers, corporate imprints, and excerpts can be created in large quantities for special needs. For more information, contact the publisher.

Other Schiffer Books by the Author:

Boston Below, Joseph R. Votano and Karen E. Hosking, ISBN 978-0-7643-4542-5

Other Schiffer Books on Related Subjects:

Shaker Furniture: A Craftsman's Journal, Timothy D. Rieman, ISBN 978-0-7643-2445-1
The Shaker Chair, Charles R. Muller & Timothy D. Rieman, ISBN 978-0-7643-1739-2
The Encyclopedia of Shaker Furniture, Timothy D. Rieman & Jean M. Burks, ISBN 978-0-7643-1928-0

CONTENTS

ACKNOWLEDGMENTS

To document and record what Shakers at Hancock would have experienced visually in their daily activities was an objective of this book. It was made possible by the help of Todd Burdick and Lesley Herzberg, staff members at the Hancock Shaker Village. A special thanks goes to Craig A. Westcott of the Darrow School, who showed me around the buildings where much of the active life of the Mount Lebanon Shakers took place. I would be remiss in not acknowledging the substantial work the Library of Congress did in putting together a digital online collection of Shaker images which included Mount Lebanon and Hancock. Further, Hamilton College of Clinton, New York, did outstanding work in putting together a digital collection of Shaker photographs and hosting a digital collection of the issues of the Shaker Manifesto spanning almost thirty years. The Library of Congress, the Hamilton College collection, and the digital collection at the Winterthur Library were invaluable in linking activities at Hancock with similar activities and scenes at Mount Lebanon. Lastly, I would like to thank the editors at Schiffer Publishing who helped make this book possible.

INTRODUCTION

PART OF THE TACONIC MOUNTAIN RANGE, traveling down the eastern side of New York State and the western side of Massachusetts, was home to two Shaker villages, Mount Lebanon (called New Lebanon before 1861) and Hancock. The latter is about four miles outside Pittsfield, Massachusetts, on Route 20 and approximately three miles to the east of Mount Lebanon. Both villages were banked close to mountainsides to provide water flow and hydraulic power to the villages through dams and aqueducts. Mount Lebanon was the vibrant voice of Shakerism for over 160 years while Hancock lived mostly in the shadows of its larger sister.

No attempted communal society has ever surpassed that of the Shakers in the last 300 years in both duration and accomplishments. Their story is about communal living, their spiritual and temporal life away from the world, and their amazing entrepreneurial drive.

After the death of Mother Ann Lee, the founder of American Shakerism, on September 8, 1784, in Niskeyuna, New York, James Whittaker took over as leader. He was definitely a zealot when it came to Shakerism and a gifted speaker. He was accepted as elder by three important leaders in the society, Joseph Meacham, John Hocknell, and Calvin Harlow. This acceptance closed the ranks and helped alleviate the shock of Mother Ann's death. It had been widely believed that she was supposed to be around for 1,000 years, something that she, herself, rejected.

A little over a year after Mother Ann's demise, on October 15, 1785, Whittaker ordered the building of a meeting house at Mount Lebanon on land provided by David Darrow. It was a gambrel-roofed structure that would serve as a symbol of the society and a place of worship to re-energize the faithful. It was built by the master builder Moses Johnson of Enfield, New Hampshire. Elder Whittaker preached the first regular service at the new meeting house on January 29, 1786. Next he took up traveling throughout New England to visit society members. The trip was cut short in March 1786 due to illness, and he retired to Joseph Meacham's home in Enfield, Connecticut. Father James died in July of that year.

Joseph Meacham, not unexpectedly, was named the new elder at Mount Lebanon. His ascension to the senior position was predicted by Mother Ann and thus expected by Shakers. She called him "the wisest man that has been born of a woman for 600 years."[1] On another occasion, she said, "God has called and anointed him to be a father to all his people in America." If only she knew just how true these prophetic words were. Joseph Meacham created the organizational structure and rules for the United Society of Believers in Christ's Second Appearing at a crucial time in the history of the Shaker movement in America. It's doubtful it would have survived as a movement if it were not for the wisdom of Joseph Meacham and Lucy Wright, whom he appointed as his equal. In doing so, Meacham established equality of the sexes and a dual role for both men and women believers. Joseph Meacham made this simple declaration on equal rights and privileges:

> All members of the church have a just and equal right to the use of things, according to their order and needs; no other difference ought to be made, between Elder or younger in things spiritual or temporal, than that which is just, and is for the peace and unity, and good of the whole.[2]

So it was in September 1787 that Meacham and Wright called for a gathering of believers at Mount Lebanon to separate themselves from the world; it was to be a self-sustaining village of believers. Local farmers David Darrow, John Bishop, Hezekiah Hammond, Jonathan Walker, and others donated their land, houses, barns, and huts to the religious cause. It was the start of Christian socialism in America in a concrete way.

By the summer of 1788 a dwelling house was built and Meacham had set down the initial organizational structure for the church. He set up three courts, later called families, by 1815, where each family had two elders and two eldresses, a deacon and deaconess, and a trustee. The latter three were involved in temporal matters with the outside world. The inner court, or Church Family, as it came to be called, was

for those believers who had freely committed their services and their property, and signed a covenant to that effect; initially it was a verbal covenant but by 1795 it was a written one, which, in turn, was partially revised in 1801. The second court was composed of young men and women who did farming and other outside work. The third court was composed of the elderly and a deacon and trustee to deal with affairs relating to the outside world.

Ann Lee had been aware that no holy order could grow and survive without an economic underpinning derived from the labor of its believers. She said,

> If you are not faithful in the unrighteous mammon, how can you expect the true riches? Labor to make the way of God your own; let it be your inheritance, your treasure, your occupation, your daily calling. You must be faithful with your hands that you may have something to give to the poor. The people of God do not sell their farms to pay their debts; but they put their hands to work, and gather something by their industry, to pay their debts with, and keep their farms. Go home, and take good care of what you have. Provide places for your things, so that you may know where to find them at any time, by day and night; and learn to be neat and clean, prudent and saving, and see that nothing is lost. Bring strength to the church, not weakness. Do all your work as though you had 1000 years to live, and as you would if you knew you must die tomorrow.[3]

With these words of Mother Ann and the diverse occupations of many of the early believers, it isn't too surprising that by 1789 a tannery, blacksmith shop, chair factory, cobbler's shop, seed business, weaving shop, and other small enterprises were up and running to fulfill the needs of the Shaker community. And eventually, by 1791, Mount Lebanon was selling a host of products to the outside world, such as hats, chairs, whips, saddlebags, cloth, and many others. Joseph Meacham appointed his brother, David Meacham, as deacon and the trustee at Mount Lebanon. He was their window to the world for the next thirty-seven years.

Order and use were highly valued concepts of Joseph Meacham and were applied throughout the Shaker society. Meacham wrote,

> All work done, or things made in the church for their own use are to be faithfully and well done, but plain and without being superfluity. All things are to be made according to their order and use; and all things kept decent and in good order, according to the order and use. All things made for sale are to be well done, and suitable for their use.[4]

Order and use was applied to building the Shaker villages. Meacham instructed Jonathan Walker, the second deacon at Mount Lebanon,

> to the chief care and oversight relating to the order of the buildings, yards and fences, to layout the order of buildings, and to see that the foundations are laid well, that the buildings are not exposed to the damaged by the frost in winter, and to see that the materials for the buildings are suitable for their use, according to the order and use of the buildings, and that the work is done in due order.[5]

In December 1790, Joseph Meacham requested that Calvin Harlow have a gathering of believers at Hancock to formalize a community there. Even before Calvin came to Hancock, the believers had already constructed a foundation for a meeting house, others had brought farm equipment and livestock, and still others contributed their household possessions. So, Hancock was pretty much a foregone conclusion, one that only needed a nudge from the central ministry (composed of Joseph Meacham and Lucy Wright) at Mount Lebanon to be a reality.

Nathan Goodrich supplied land for the Church Family, and John Deming supplied land for the Second family. Then in the early 1790s the West family was formed from the farm of Josiah Tallcott Sr., and the East and South families from the Cogswell, Wright, and Boyington farmlands. Some of the Tallcotts joined at Mount Lebanon and others at Hancock. Around forty members of the Goodrich families joined the Shakers by 1800, some to each village. Although there is no supporting documentation, it's hard to imagine that there were not some personal relationships connecting the different spiritual families at Mount Lebanon and Hancock, even though Millennial laws of 1821 would forbid members of different families from interacting with one another whether in the same village or not.

By 1792 the gospel order of Shakerism was completed. A central ministry was at Mount Lebanon. Leadership in each village family was composed of two elders and eldresses, a deacon and deaconess, and a trustee. The central ministry appointed branch ministries called bishoprics that were the ministry for two or more villages. The ministry selected and appointed the elders and eldresses for each family within a village. In the next few years the written covenant of 1795 was then put in place.

It's worth noting that in its preamble the essence of "joint interest," or common ownership, of property was the focal point:

> For it was and still is our Faith, and confirmed by our experience, that there could be no Church in Complete order, according to the Law of Christ, without being gathered into one Joint Interest and union, that all the members might have an equal right and privilege, according to their Calling in needs, and things both Spiritual and temporal. And in which we have a greater privilege and opportunity, of doing good to each other, and the rest of mankind, and receiving according to our needs Jointly and Equally, one with another, in one Joint union and interest.[6]

Over a period of ten years Joseph Meacham had worked tirelessly to create a religious-communal-industrial society from a somewhat scattered and disorientated group of believers. He put the Church on a firm economic footing for growth and survival as Mother Ann had stressed. He also gained more acceptance of the society by the world. In the early summer of 1796 Joseph Meacham returned to his beloved Enfield, Connecticut. He took ill and died on August 16, 1796, after twenty years working for the cause of Shakerism. It wasn't in vain. In just seven years after his death, the number of Shakers reached somewhere around 1,600 in eleven different communal villages in the Eastern United States; in 1774 there were just eight members in Mother Ann's church. It grew roughly six-fold in forty years from 1,000 followers in 1800 to roughly 6,000 spread over fifty-eight families in eighteen communal villages by the 1840s.

What factors drove the initial growth from 1800 to 1850? Edward Deming Andrews, a noted Shaker scholar, attributed such growth to several factors:

- Shaker religious principles, which inspired people

- Economic well-being, security, and a contributing occupation

- The cohesive forces of communal organization (i.e., working, dancing, living together)

- Religious revivals of 1805, 1827, and 1837 through 1850

- Control over the sexual relation, maintaining celibacy

- Villages functioned as sanctuaries (i.e., homes for abused women, orphanages for children)

Most important was the idea that labor was consecrated. It was the foundation upon which the Shaker society rested. Manual labor was glorified. It was absolutely needed for the social welfare of the community. It gave dignity to the individual and enhanced one's self-worth, it provided a surplus for charity, and it protected, as much as possible, the community from intrusions from the outside world. The fact that labor was a sacred obligation conducted by all (the common Shaker young and old, the ministry, the elders and eldresses, the deacons and deaconesses) may, in part, explain the order, the sense of permanence, the quality of their workmanship, and the tranquility that prevailed in Shaker villages.

James Fenimore Cooper, the American novelist, had paid a visit to New Lebanon around 1825 and very likely to the Hancock Shaker Village as well. He characterized this atmosphere this way: he "had never seen, in any country, villages as neat, and so perfectly beautiful, as to order and arrangement, without, however, being picturesque or ornamented, as those of the Shakers."[7]

Labor was relatively free and plastic; it didn't become rigid and highly regulated. Development of the native ability of an individual, encouragement of individual initiatives, developing skills in diverse occupations to gain satisfaction and pleasure, and work with moderation to eliminate excessive toil: these were the objectives of work, not by compulsion but by desire. This was a Shaker legacy.

Interestingly, most members had at least two occupations and, in some rare cases, up to ten or more. Considering sex, age, and ability, one was assigned a job to one's liking. Once one mastered a trade, one could apprentice to learn another, with one exception: the kitchen deaconess. That was a permanent job.

The flexibility and the idea of consecrated labor made for a successful economy for most of the nineteenth century despite the inevitable encroachment of industrialized capitalism on the Shaker way of life. It was their religious concept of oneness with Christ, the unity of spirit, fending off the outside world, improving one's abilities, the sacredness of work, and unselfishly assisting one another that were decisive elements in establishing a successful economic foundation that carried many villages through good and bad times.

These concepts were the legacy laid down by the Shakers. There were always, of course, petty differences and antagonistic behavior between some believers but, for the most part, it was rare. There were several self-serving trustees as well, in the history of the Shakers, who enriched themselves at the expense of their brothers and sisters, but such trustees were uncommon. Some Shaker apostates, those who left, brought suit against Shakers for lost income and property. The great majority of these apostates' cases were treated fairly by the Shaker elders and eldresses.

Deacons and deaconesses were department heads overseeing workers; for example, a farm deacon, a mill deacon, a garden deaconess. The deacon or deaconess was responsible for satisfying the internal needs of the family in terms of both agricultural and non-agricultural goods produced by the family. Each family in a village had its own trustee's office and store to handle incoming and outgoing goods and to act as a supply house for the family. Fixed assets, on the other hand, were handled only by the trustee, as were transactions with the outside world in the buying and selling of goods. Families sold or bartered goods among each other, and sold or bought goods with the outside world. In some instances the deacon or deaconess also interfaced with the outside world in business dealings, mainly regarding the selling and buying of goods.

Most families had fifty or fewer members, so the organizational structure was not burdensome. Agricultural produce and products derived from plants (e.g., seeds, herbal medicines) were the big sellers throughout the nineteenth century, followed by products such as chairs and fancy goods. Of course, there were economic ups and downs due to changes in the markets of the outside world that impacted the business of many Shakers. The commercial textile industry finally put an end to their cloth business. The Civil War temporarily crushed the seed business for many Shaker communities, since much of their sales were in the South. Nonetheless, communities, for the most part, bounced back with new businesses. It was the steady decline in membership from 1870 to 1900 that was the major factor in the rather rapid transition from an order of brethren and sisters to one mainly of sisters.

THE VILLAGES

For the ordinary Shaker, it was membership in a specific family that brought cultural life and social recognition to the believer. Being a member of the greater Shaker society was, very likely, of a secondary concern to the average Shaker since there was little interaction between families or villages; so there was little sense of the whole. One's life centered on close personal friends within the family; they slept together, ate together, did daily chores together, worked together in the shops, and together attended both religious activities and union meetings, which were small, weekly gatherings of brothers and sisters to air their opinions on various subject matters related to their village. In keeping with the Millennial Laws, believers, except trustees and deacons, could not leave the village without permission from an elder or eldress. This was in keeping with the sectarian nature of Shakerism to withdraw from the outside world. So in fact, during the early to mid-1800s, the Shaker village and its surrounding land was the world for the vast majority of believers of that village. What this also tells us is that the village families had to be reasonably self-sufficient. Maps can tell us something about how villages were structured and organized, and can help us to get an idea of their physical environment.

To one's surprise, there are only a few nineteenth-century maps of the villages of Mount Lebanon and Hancock. Since they were either enlarging buildings, building new ones, moving old ones, or selling or acquiring more land, it would seem that the Shakers would have mapped out villages on some regular basis, for instance, every decade or so. Possibly, rather than not ever being made, maps were lost, maybe to fire; nonetheless, there are two maps one can use.

Plate 1 shows an 1820 map from the Hancock Shaker Village collection of the Church Family holdings at Hancock. The artist is unknown and

the lettering was redone to make it legible, but the drawings of the buildings are original except for the removal of distracting dots surrounding buildings. In just thirty years from its formal founding in late 1790, the Shakers, led by Elder Nathaniel Deming, Eldress Cassandana Goodrich, and Deacon Daniel Goodrich, oversaw the completion of thirty-two significant structures at Hancock.

Note that the majority of buildings ran parallel to the main road, today's Route 20. Situating buildings in a line parallel to a major road was a common structural feature in most Shaker villages. Every village had a communal meeting house. At Hancock it was across from one of the two dwelling houses. The Church Family was composed of forty brothers and fifty sisters in 1819, who were split into two orders, first and second; hence, two dwelling houses. There are eight shops to supply family necessities and products to sell to the outside world: a clothier, tannery, blacksmith, hatter, dairy, dyeing house, cider mill, and a machine shop. Many believers were craftsmen and tradesmen with all sorts of skills, which made it possible to be reasonably self-sufficient in the early years from 1790 to 1820.

The latter is the start of what historians call the classical Shaker period, 1820 to 1860. The large number of barns, five alone for the Church Family, is indicative of an agriculturally based economy, where the Shakers tried to raise essential foodstuffs: meat, grains, fruits, vegetables, and dairy products. The latter was the principal farming objective at Hancock. In some villages Believers were successful, and they were marginal in others. Hancock did reasonably well in its farming endeavors, partly due to the entrepreneurial trustees over the years at Hancock.

The schoolhouse was being constructed in 1820, which is probably the reason there is no school drawing on the map, just a blank location. It was to serve the three families at that time: Church, East, and West. The community was also serviced by a communal nurse shop/infirmary.

At this time there were 222 Shakers in the Hancock community as a whole, of whom 132 came from families other than the Church Family. Not long after, three more families were created; the North, South, and the Second, with the Hancock village topping out at 300 believers in six families, with land holdings of around 2,700 acres, in the early 1840s.

Mount Lebanon was the central ministry, which made leadership appointments throughout the Shaker communities and made the governing rules for the gospel order for eighteen communities spread out from New England to Kentucky to Ohio, and to a short-lived Florida community.

Mount Lebanon was in the forefront in developing business opportunities, acting as the voice for the Shaker communities, and as guardian of the Shaker faith. A primary occupation of the order was to develop the land. Besides crop growing, seed gardens were established. Up and down the East Coast, packaged seeds from Mount Lebanon and other Shaker villages were well known. In some years hundreds of thousands of various seed packages were sold, which made the business quite lucrative for Shakers. The seed business lasted until the early 1890s. Medicinal herbal medicines followed the seed business, starting up around 1820, and was enormously profitable for Mount Lebanon. These businesses, together with broom and chair businesses and others, propelled Mount Lebanon's growth during the classical Shaker period. By 1839 the community had grown to 125 buildings. Further growth took it to 6,000 acres, 150-odd buildings, and 600 believers among eight families: the Church, North, Center, East, South, Second, and the upper and lower Canaan Families by the early 1840s.

To put the geographic size of Mount Lebanon into perspective at that time, it was 41% of the size of Manhattan Island. One can image the physical infrastructure needed to maintain the village with its land. Unfortunately, no existing map seems to exist giving detailed descriptions of buildings in the mid-1800s. Henry Blinn of the Canterbury Shakers drew a map of Mount Lebanon sometime in the 1840s, but didn't designate what the buildings were, just their size and location, and only for a few of the families.

Today people rely on a detailed map drawn by A. K. Mosley in 1939 while he was working on a project called the Historic American Buildings Survey, a project of the US Department of the Interior. Plate 2 is Mosley's map, which shows the layouts for the core five families. The village proper was quite large; it was 2.7 miles from point A (lower left) to point P (upper right) on the map, equivalent to going from 42nd to 96th Street in Manhattan. By all appearances Mount Lebanon was more like a good-sized New England town rather than a village, with its ninety-odd structures shown on the 1939 map.

One can see from the detailed description of the structures that each family had one or more dwelling houses (residences), one or more barns, and several workshops. Building 14 of the North Family was the Great Barn, thought to be the largest in New England. Workshops numbered around seventeen throughout these families. Eleven barns for storing of feed and housing of livestock were scattered among the families.

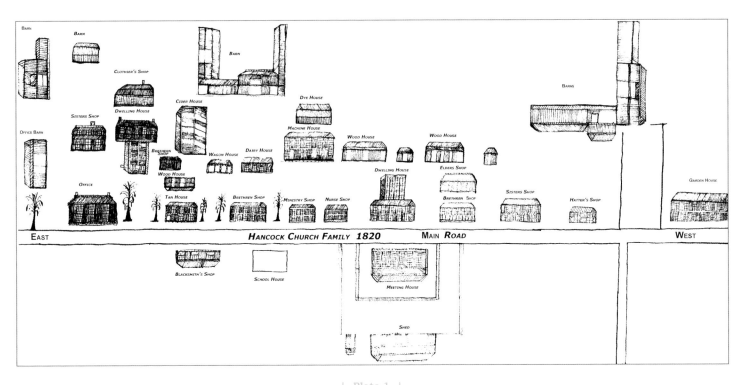

BARN BARN BARN CLOTHIER'S SHOP CIDER HOUSE DYE HOUSE BARNS OFFICE BARN SISTERS SHOP DWELLING HOUSE MACHINE HOUSE WOOD HOUSE WOOD HOUSE BRETHERN SHOP WAGON HOUSE DAIRY HOUSE DWELLING HOUSE ELDERS SHOP GARDEN HOUSE WOOD HOUSE OFFICE TAN HOUSE BRETHREN SHOP MINISTRY SHOP NURSE SHOP BRETHREN SHOP SISTERS SHOP HATTER'S SHOP

EAST HANCOCK CHURCH FAMILY 1820 MAIN ROAD WEST

BLACKSMITH'S SHOP SCHOOL HOUSE MEETING HOUSE SHED

| Plate 1 |

1820 Map of the Church Family holdings at Hancock

Most important were the water-powered mills, saw and grist, found among the Church and North families. Both power mills not only satisfied internal needs but brought in revenue from local farmers who needed lumber sawn from their logs or flour milled from their grain.

Building 2 of the Church Family at Mount Lebanon was the communal meeting house, with its barrel-shaped roof.

Of the original eight families, the South and East were dissolved in 1854 and 1872, respectively. In 1930, the Lebanon School for Boys (later the Darrow School) bought forty buildings and 300 acres from the Church Family for $75,000. It was the start of the first sell-off of Church Family assets at Mount Lebanon into private hands. In October 1947 Mount Lebanon was closed, with the last three sisters, Grace and Mary Dahm and Jennie Wells, being moved to the Hancock village. The Darrow school then bought up all remaining Church, Center, and Second Family lands and buildings.

Later, in 1973, the Abode of the Message, a Sufi community, purchased the South Family holdings and remains there today.

In 2004 the North Family property of some thirty acres and ten buildings was purchased by the Shaker Museum and Library at Old Chatham, New York. Renovation and restoration of the buildings are ongoing at the North Family site. It's hoped that eventually a new museum will be built at the site to house the enormous collection of Shaker furniture and other artifacts owned by the museum.

The closing of Mount Lebanon was a defining moment in Shaker history. It was, in a sense, a signal of defeat. The society recognized it was in trouble but could do little to alleviate its financial problems or reverse its continually declining membership; from a high of between 5,000 and 6,000 believers around 1840, to 2,415 by 1875, to 794 in 1900, to 213 in 1925, and then by 1950 to 46 members in three communities—Hancock; Canterbury, New Hampshire; and Sabbathday Lake in Maine. From 1875 to 1959 the

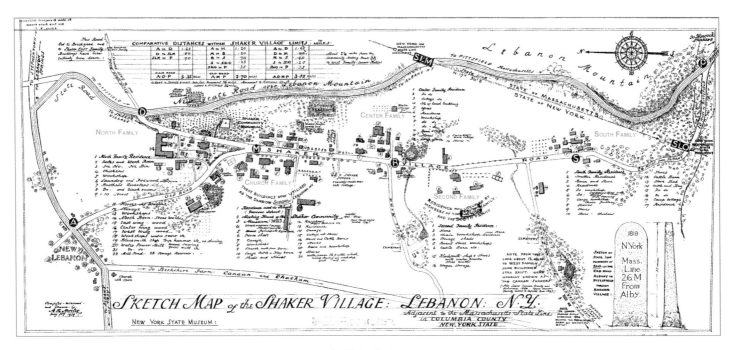

Mount Lebanon Shaker Village as of 1939

membership declined by 98%, with the most precipitous drop of 78% occurring from 1925 to 1950. It was a gut-wrenching time for the Shakers: uprooting their homes, selling off Shaker belongings, demolishing buildings to reduce their tax load, the old caring for the old, and then watching their friends die off. By 1870 the majority of believers were women, about 63%, and this grew to be over 95% by 1950.

Hancock followed pretty much the same trajectory of declining membership as did the United Society of Believers as a whole. It went from a maximum around 300 believers in 1840, to 123 by 1870, to 43 members in 1900, and finally to five or six members in 1956. With the death of trustee Frances Hall in March 1957, the death of brother Ricardo Belden, the last male Shaker at Hancock, in December 1958, and then the passing away of eldress and trustee Fannie Estabrook at age 90 in September 1960, the central ministry at Canterbury, New Hampshire, decided to sell off Hancock. It was ironic that the day

Fannie Estabrook died was the day the drive started to preserve her home of eighty years. She came to Hancock at age ten, became a trustee in 1919, and later eldress, in 1929—the last of the village's leaders. She was buried at the Shaker cemetery across Route 20 from the Trustee's House at Hancock. As of 2015, there are three Shakers left at Sabbathday Lake in Maine.

INDUSTRIES

FROM ITS VERY BEGINNING, the leaders of the Shaker movement realized its survival depended upon industry and trade with the outside world. Although the Shakers were separatists from the world, they were not economic separatists by any stretch of the imagination. Among the movement's converts were artisans, mechanics, tanners, tailors, blacksmiths, coopers, cobblers, weavers, millers, and skilled craftsmen of other trades. The skills existed to create, at first, fairly self-subsistent villages with each family involved in one or more small industries. Although the families were economically autonomous, they traded with one another and in times of need assisted one another. Likewise, Shaker communities helped one another when the need arose.

Agriculture was the principle mainstay in the nineteenth century for both Hancock and Mount Lebanon, as it was throughout all the Shaker communities. Edward Deming Andrews, the noted Shaker historian, put the relationship between the soil and Shaker beliefs very succinctly:

The Shakers were among the first in this country to see more than the obvious possibilities of gardening, and here, as in many other fields, their habitual genius for recognizing and developing economic opportunities is apparent. The passion of the people composing this sect for being useful, for doing useful things and for making useful things is evidenced in these soil activities. It was consistent with their pragmatic philosophy that plants should be utilized in every way possible.[8]

In the words of F. W. Evans, a leading Shaker:

Thus, when a Shaker is put upon the soil, to beautify it by his tilth, the difference between his husbandry and that of the Gentile farmer, who is thinking solely of his profits, is likely to be great. While the Gentile is watching for his returns, the Shaker is intent upon his service. One tries for large profits, the other strives for good work.[9]

It's impossible to state with certainty where the first venture into the seed business occurred. It was either at the first Shaker community, Watervliet (previously called Niskeyuna), just south of Albany, New York, or at the Church Family at Mount Lebanon. In 1795, sales were recorded at Mount Lebanon totaling $406 for onion, beet, carrot, and squash seeds. The Shakers were the first to sell seeds in packets or bags.

By 1825 the seed business was taken up by specific families throughout the eighteen communities. The sisters cut and pasted seed packets, in some years amounting to 286,000 per year at the Church Family at Mount Lebanon; from 1836 to 1840 the number of packets printed at Mount Lebanon was 930,400.

By 1835 Mount Lebanon offered more than seventy varieties of seeds. The business of selling extended to New York City, Philadelphia, Baltimore, all of New England and New York State, throughout the South, and even into Canada. Shakers received two-thirds to three-quarters of the sales price from their distributors and retailers. The quality of the products was very high and so were the prices. The seed business was a big revenue generator for the Church Family; during the period from 1795 to 1820 they took in $33,901 from seed sales. To put this number into perspective, it is equivalent to $1.76 million today.

A seed industry operated in most Shaker communities. Even at Mount Lebanon, the Second and North Families were also involved in the seed business, not just the Church Family.

Initially the American Civil War put a damper on sales, mainly due to destruction of many southern farms, but by 1867 sales picked up to their pre-war level. This was due, in part, to the Shakers taking up worldly-type advertising; colorful posters and bags helped promote the seeds, which were put into colorful seed boxes (see Plate 4).

Little is known about the seed business at Hancock other than that in 1813 a garden list was put out listing thirty-five varieties of seeds; that increased to sixty-nine varieties by 1869. In 1842 Hancock printed up 122,900 seed packets. Whether they sold that many is unknown. Nonetheless, Hancock was definitely in the seed business.

In the early 1880s the seed business was faltering. At Mount Lebanon the business was reorganized in 1884 and called the Shaker Seed Company of Mount Lebanon, with Elder D. C. Brainard in charge. The mail-order business in seeds was the primary focus of the new enterprise. It hobbled along until its closure somewhere around 1890.

What eventually caused the demise of the seed business in all communities by the late 1880s? One suspects it was worldly competition, plus the decline in male Shakers to handle the farming and harvesting of seeds. By 1875 there were 887 males in eighteen Shaker communities, but only approximately 337 between the ages of twenty and sixty, spread among the villages' fifty-eight families. So, the average number per family was just under six middle-aged males. Given that the brethren were involved in other trades besides farming, the number available to farm could easily be less than three per family.

The labor issue is an important one when it comes to sustainable agriculture. Yes, they could hire outsiders, which they eventually did, but then it would cost much more to produce seeds. The Shakers could not continue to be price-competitive as well as maintain their renowned quality.

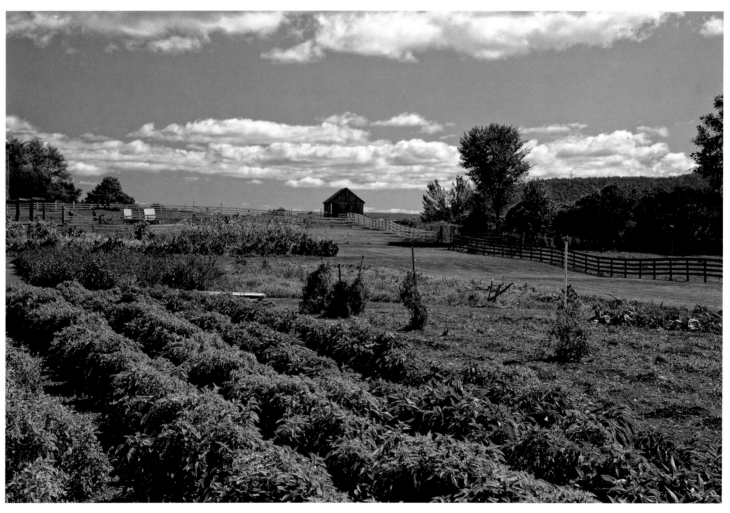

| Plate 3 |
Seed garden at Hancock Shaker Village

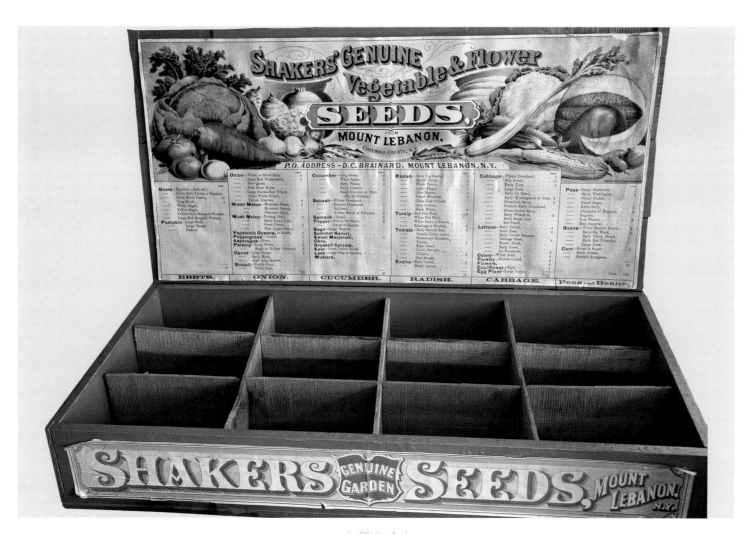

| Plate 4 |

Seed box with listing of seed packets

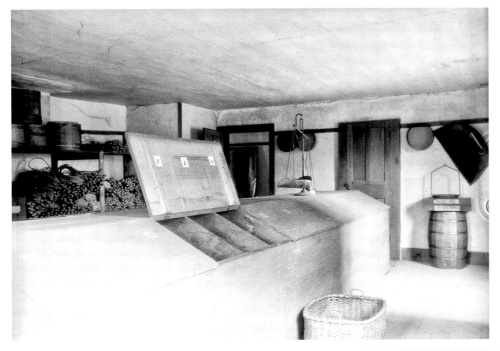

Seed bins at Mount Lebanon

Once seeds were dried, they were placed in bins until packaging (see Plate 5).

Shakers usually put what one could call a "seal of quality" on many products they sold. It was the initials of the trustee or deacon responsible for the business dealings.

Note the letters *E. F.* on the instruction label in Plate 7. These stand for Edward Fowler, a deacon for the Church Family in charge of the seed business.

D. G. in Plate 6 probably stands for Daniel Goodrich Jr., a deacon at the Church Family at Hancock.

SHAKER SEEDS.

EARLY

WASHINGTON PEAS.

For early use, soak the seed in water 24 hours; sow (during the month of April) in good soil, in double rows, 6 in. apart, and 4 ft. between the rows. Cover the seed 1 to 2 inches deep. **D. G.**

WEST PITTSFIELD, MASS.

| Plate 6 |
Instruction label

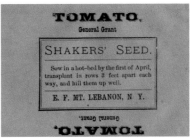

TOMATO.
General Grant

SHAKERS' SEED.

Sow in a hot-bed by the first of April, transplant in rows 3 feet apart each way, and hill them up well.

E. F. MT. LEBANON, N. Y.

TOMATO.
General Grant

| Plate 7 |
Instruction label

A natural outgrowth of the Shaker seed industry was the focus on medicinal herbs. Just about twenty-five years after the first seed sales came the first herb sales at Mount Lebanon in November 1821, a whopping sale of $1.15. Doctors Eliab Harlow and Garrett Lawrence had laid out gardens for medicinal herbs in 1820. By 1831 about 4,000 pounds of roots and herbs went to market; that grew to 16,500 pounds by 1849.

There were five major Shaker producers of medicinal herbs and herbal medicines: Mount Lebanon; Canterbury, New Hampshire; Harvard, Massachusetts; Watervliet, New York; and Union Village, Ohio. It is astonishing how much income was derived from herbs. From 1825 to 1900 the total annual income from these five communities was put at $150,000 annually; in today's dollars it amounts to $7.8 million annually. At Mount Lebanon alone, some fifty acres were cultivated for hyoscyamus, belladonna, taraxacum, poppy, sage, some 200 varieties of indigenous plants, and some forty varieties from the south and the west. Current gardens at Hancock Shaker Village are seen in Plates 8 and 9.

| Plate 8 |
Vegetable garden at Hancock Shaker Village

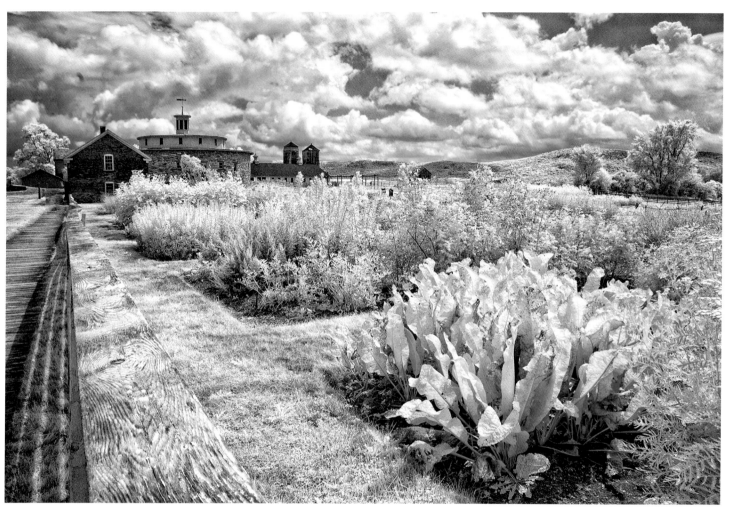

| Plate 9 |

Garden at Hancock Shaker Village, infrared image

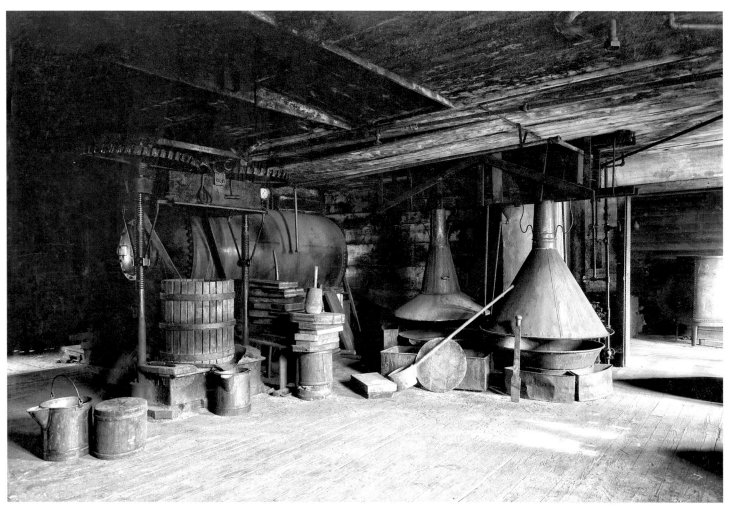

| Plate 10 |

Vacuum pans used in herbal extraction at Mount Lebanon

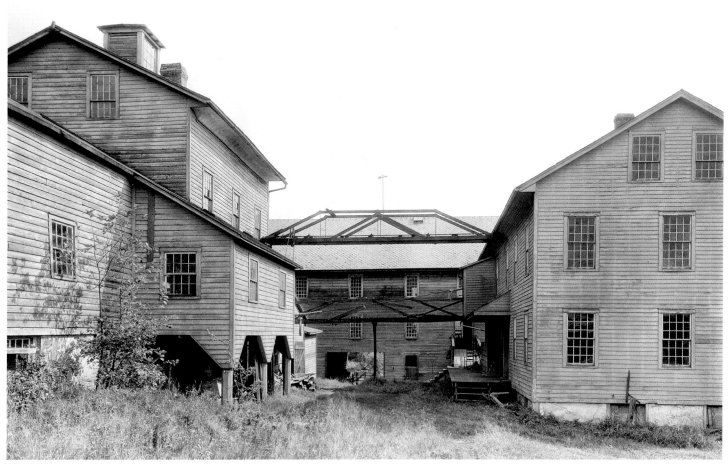

| Plate 11 |

Herb houses at Mount Lebanon

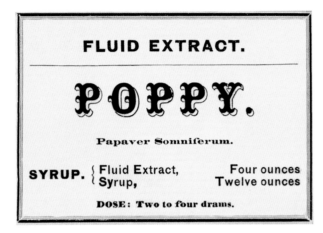

| Plate 12 |

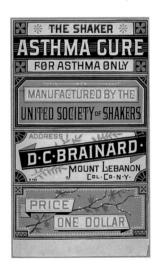

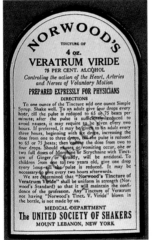

| Plate 13 |

| Plate 14 |

| Plate 15 |

Label for Shaker Extract of Roots. Note A. J. White's signature at the bottom.

In the years from 1852 to 1857, new 300-ton presses, copper vacuum pans for drying herbs and extracts, and new steam engines and machinery were installed at Mount Lebanon. A new vacuum extraction process was introduced to concentrate medicinal extracts (see Plate 10). Controversy erupted as to who invented the process, the Shakers or the Tilden Company. It was never resolved.

There were three types of products: packaged herbs, ones used as topical agents, e.g., skin and hair treatments, and those for internal use sold as bottled remedies. Ten workers, sometime twenty, labored in the two-story herb house (see Plate 11). The basement was for hydraulic pressing, grinding, and other heavy work, while the first floor workers did the packing, papering, printing, and storing of the products. The second floor and loft were for drying and storing.

Packaged herbs, roots, and barks were usually sold in one-pound bricks, with hundreds of varieties being offered. Sales were direct, through distributors, or through local pharmacists. External agents ranged from perfumes and hair dyes to hair restorers and such products as witch hazel.

In the nineteenth century, opium was not a controlled or restricted substance. When dissolved in alcohol, the tincture of opium was taken as a pain killer, as a sleeping aid, and as a relaxant. So it is no surprise that the sisters at New Lebanon were out before sunrise slicing the poppy pods, then returning at sunset to scrape off the raw opium from the pods. It was sold as a fluid extract (see Plate 12). The opium business was quite lucrative for the Shakers.

They created many remedies, even one for asthma. The Shaker Asthma Cure (see Plate 13) was manufactured in the 1880s and 1890s. Although the formula was never disclosed, speculation points to the antispasmodic herb lobelia as the possible active ingredient. Another big seller was Norwood's Tincture of Veratrum Viride (NTVV) (see Plate 14). Although it was poisonous at high dosage levels, it was a phenomenal seller for lowering fevers. Dr. Norwood, a physician from South Carolina and the inventor of NTVV, granted rights to the Church Family to sell NTVV in 1858 under a royalty agreement, and then in the mid-1870s he gave full rights to the formula to the Shakers. This drug had an eighty-year association with the Church Family at Mount Lebanon. In 1859, 143 bottles were put up. By 1871 production reached 14,079 bottles annually. The active ingredient in the tincture was an alkaloid that depressed the heart rate and respiratory muscles. These effects, in turn, caused a slight lowering of a fever accompanying an infection. The production of NTVV continued into the early 1940s.

When matters looked bleak after the fire of 1875 at Mount Lebanon (see "Fire Fighting" on page 104), Benjamin Gates, the trustee, looked for new sources of revenue for the Church Family and the community. He struck a deal with Andrew Judson White, who was attempting to make and sell his Mother Seigel's Syrup out of a rather run-down shop in New York City. Mount Lebanon agreed to put up the several thousand dollars needed to buy the business, and the name was changed to the Shaker Extract of Roots as seen in Plate 15. The syrup remedy was nothing but one among many already existing laxatives, consisting of sixteen ingredients, mostly herbs grown at Mount Lebanon, which were dissolved in a viscous sugar solution. As the thinking went at that time, a person suffering from constipation was poisoning the body with waste products, bringing on dyspepsia. Despite its unoriginal makeup, it became the world's largest distributed remedy. By 1890 A. J. White claimed to have had sales agents in eighty-four countries.

By 1900 all the Shaker communities, with one exception, were out of the medicinal herb business and in the handicraft business, again as a result of declining male members. The exception was Mount Lebanon; it exited the medicinal herb business in the early 1940s. The fact that the business of medicinal herbs in the United States started with herbal medicines made by the Shakers, which they then developed into a business that lasted around 120 years, is truly remarkable. Hundreds of products came into being through Shakers' genius in developing ways to make things useful, which was the Shaker way.

Probably no objects are more immediately identified as "being Shaker" than the Shakers' furniture, especially their chairs. All villages made furniture for use by their members. It occurred over and over: something useful was made to assist the Shakers, and eventually it became a product to sell to the world. Chairs were no exception. In fact, chairmaking became what one might call a heavy industry, at least for the Shakers at Mount Lebanon. The first reported sale of chairs there took place in October 1789. Three chairs were sold to an Elizah Slosson for the princely sum of 11 shillings, somewhere around $52 today, as recorded by Joe Bennett Jr. in the trustee's account book of the Church Family. Still, most chairs made during the next seventy years were principally for use by the Shakers. A small number of chairs were made for sale at Mount Lebanon and other villages, but nothing in the way of a significant quantity. This was about to change.

Prior to 1863, the Second Family at Mount Lebanon was the maker of a limited number of chairs, employing the talents of James Farnum, John Lockwood, and Gilbert Avery. Then, in 1863, the South family was formed, a split-off from the Second Family. Brother Robert Wagan (1833–1883), who previously managed chair production in the Second Family, was now appointed the new shop deacon for chair production for the South Family. From 1867 to 1874 chair production underwent standardization, with different sizes of chairs for sale (see Plate 16). With so many different sizes, ranging from the smallest, size 0, to the largest, size 7, and different styles, production had to be done on an assembly-line basis, or at least partially so; otherwise confusion would result in what pieces went where. In 1871, a new factory was built at the South Family at a cost of $25,000. It contained a 15-hp engine, probably to drive lathes and other machinery, and a 20-hp boiler for the heating system. Plates 17 and 18 show the chair factory at the South

Family in the 1930s and as it is today. Plates 19 and 21 show the sisters' weaving room where chair seats were woven, and the second floor production room at the Second Family chair factory, respectively. Ten workers could produce about two dozen chairs per day in 1872.

Rockers became popular after the 1860s as the Shaker membership aged (see Plate 23). Chair frames were constructed mainly from maple wood, with some made from cherry, birch, or butternut. Some designs used a taped back as seen in Plate 24, showing a logwood stained chair. Others used a three-slatted or four-slatted back (see Plates 24 and 28). An ingenious device, a simple ball-and-socket arrangement attached to the base of the rear legs of a chair, allowed the chair to be tilted back, preventing wear on carpets or marring of floors. They were made of wood or, in rare cases, metal, as shown in Plate 25. Brother George O. Donnell invented the metallic tilters and received a patent in 1852.

Under Wagan's management, a catalogue listing all chairs came out in 1874. Two years later, their chairs were first exhibited at the Philadelphia Centennial of 1876. The world was introduced, in a big way, to Shaker craftsmanship via chairs.

Sales from the South Family were direct to consumers via their many catalogues, from their showroom at the South Family (see Plate 27), or through selected retailers throughout the country. Although sales figures are sparse, sales must have been reasonably robust since imitation chairs became a problem as early as 1875.

With the death of elder Wagan in 1883 and continual decline in membership, there was a steep decline in chair production by 1890. The last two sisters at the South Family, Sarah Collins (see Plate 22) and Lillian Barlow, labored until the very early 1940s, after which the century and a half of chair production ceased, closing another chapter of the Shaker industries.

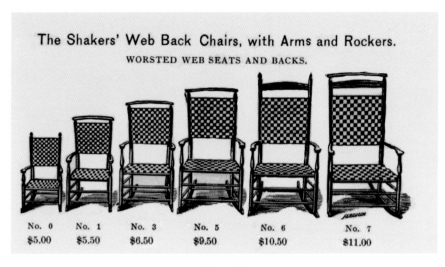

The Shakers' Web Back Chairs, with Arms and Rockers.
WORSTED WEB SEATS AND BACKS.

No. 0	No. 1	No. 3	No. 5	No. 6	No. 7
$5.00	$5.50	$6.50	$9.50	$10.50	$11.00

| Plate 16 |

The 1871 chair building shown in Plate 17 was connected by a walkway to the third floor of the sisters' laundry and chair shop. The skeletal chairs were carried from the factory across the walkway to the sisters' workshop to be completed. The sisters wove the tape seats and backs for the chairs, a very laborious task. Toward the 1900s, due to scarcity of sisters, commercial tapes were used rather than hand-made ones.

Plate 18 is what the 1871 chair factory looks like today—not that much different from the 1930s image, Plate 17.

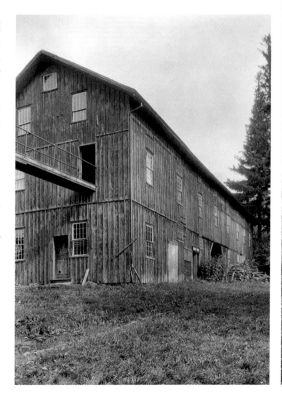

| Plate 17 |

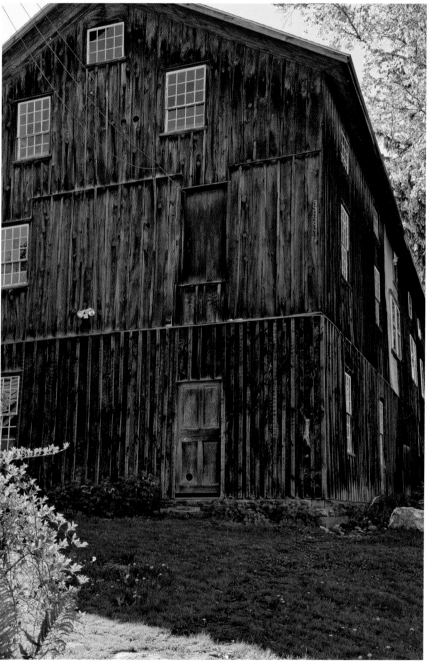

| Plate 18 |

| Plate 19 |

| Plate 20 |

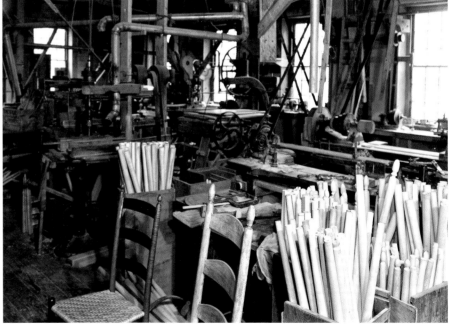

| Plate 21 |

The sisters' chair shop (Plate 19) was located next door to the brethren's chair factory. Here the chairs were completed, and trademark decals with chair sizes (Plate 20) were pasted onto the back of the slats. Trademarks were necessary to deter knockoffs that were coming onto the market.

One can see that the chair factory at the Second family lent itself to some degree of mass production, with a mechanized setup for doing most of the woodworking. Plate 21 was taken in 1938.

Sarah Collins (1855–1947) was the last eldress and Shaker of the South Family at Mount Lebanon. She came to the village in 1863 and stayed over eighty years. Her gnarled hands attest to the hard work she performed in weaving over many years at the sisters' chair shop.

She was born in Boston and never really knew her father, who was killed in the Civil War, nor her mother, who died when she was young. She was brought to the Shakers at age seven.

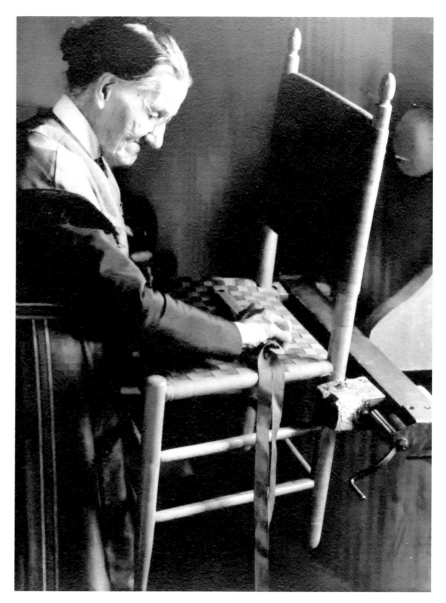

| Plate 22 |

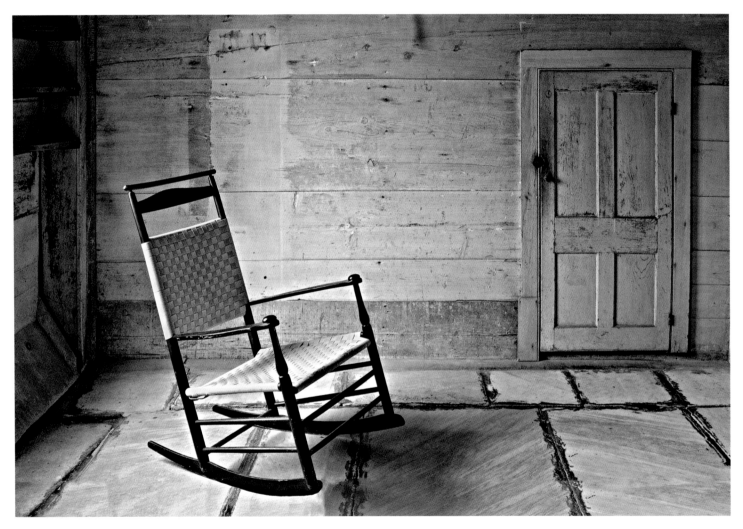

| Plate 23 |

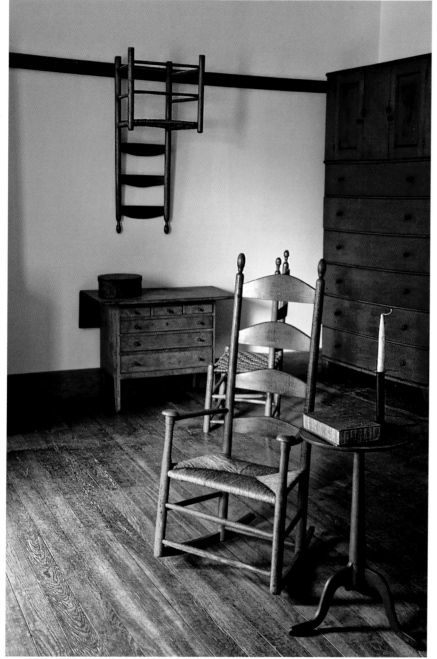

| Plate 24 |

| Plate 25 |

| Plate 26 |

Metal tilters patented by George O. Donnell in 1852. Most tilters were wood; metal ones were quite rare.

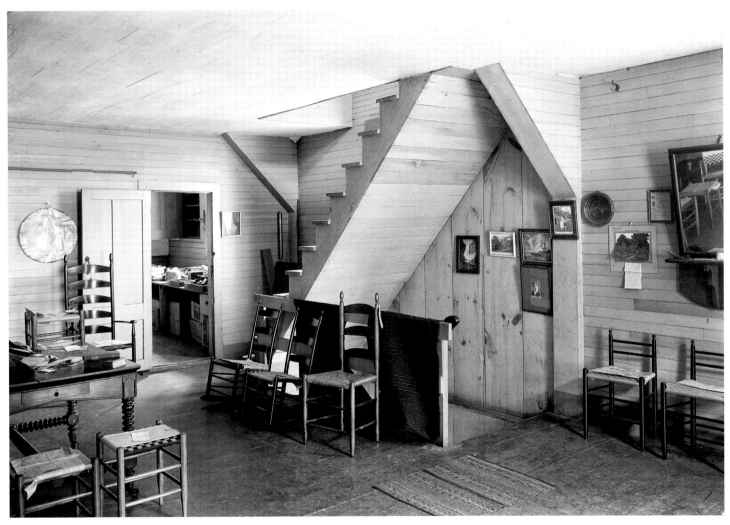

| Plate 27 |
Chair salesroom at the South Family at
Mount Lebanon in the 1930s

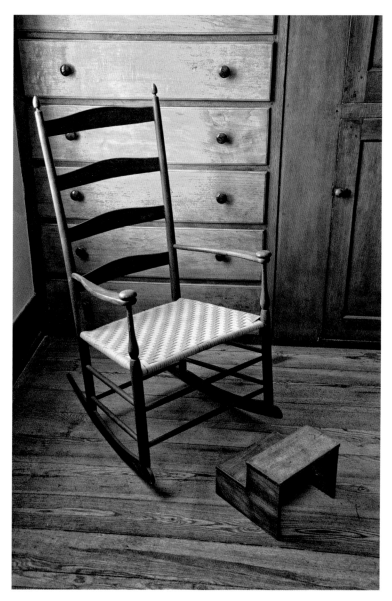

| Plate 28 |

SECONDARY INDUSTRIES

Innovation was a trademark of the Shakers when it came to industry. It was manifested in the many different products they made. Shakers made hundreds of items, some for internal use only (like shoes) and many for sale to the outside world through catalogues, their own village stores, and through retailers and distributors. Probably the best known and most recognized items were brooms and brushes, swifts, cloaks, and fancy woodenware such as oval boxes. All of these composed what one could call the secondary industries: not large revenue generators but reasonably adequate for a cottage industry.

BROOMS, BRUSHES, AND SWIFTS

Around 1800 Brother Theodore Bates (1762–1846) of the Watervliet Shaker community is credited with inventing a special vise to flatten out the bristles of broom corn to make it more efficient than the standard, normal, round broom of the time (see Plate 29). By 1805 broom corn was grown on a large scale in the Lebanon valley and in Western Massachusetts; most Shaker villages were involved in making brooms. This was certainly the case at Hancock and especially at Mount Lebanon, where several families made brooms that were sold for anywhere from $0.20 to $0.50 per broom, according to size, in places like Albany, Boston, and throughout the Hudson Valley.

The broom business continued into the 1860s for the Church Family at Mount Lebanon, and then died out soon after. However, other villages, especially Shakers at the Shirley, Massachusetts, community, made and sold brooms well beyond 1860.

Cleanliness was a way of life with Shakers. Sweep away sin, sweep away dirt: they went hand and hand. The broom was not to be hidden behind doors when not in use, but hung on a wall (see Plates 30 and 31). Given the Shakers' cleanliness in both temporal and spiritual matters, the making of brooms was a natural endeavor.

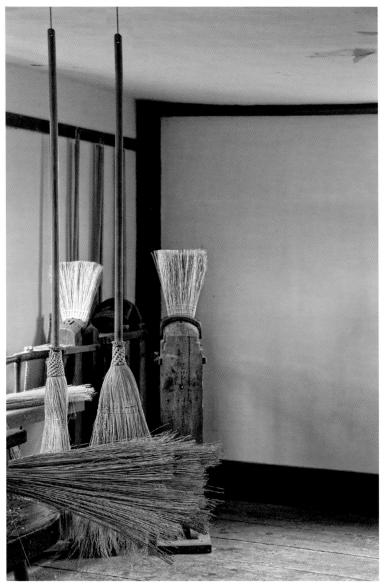

| Plate 29 |
Broom making at Hancock Shaker Village

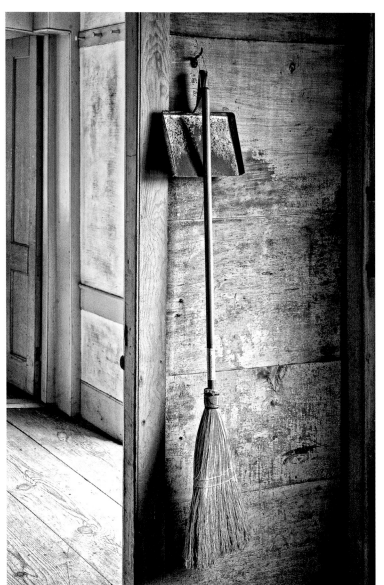

| Plate 30 |
Laundry and Machine Shop at Hancock

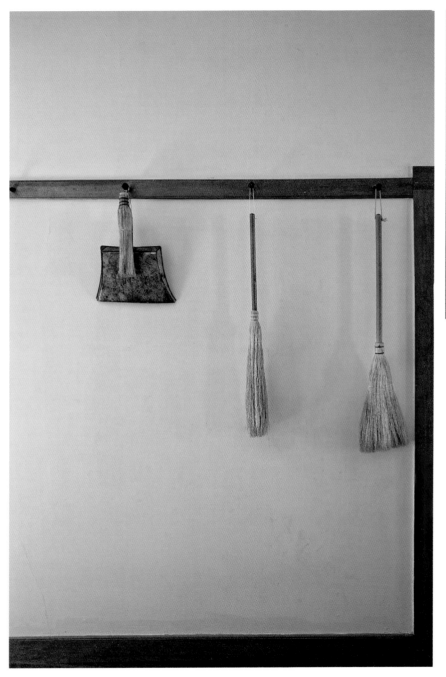

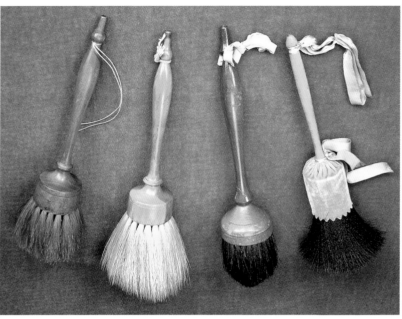

| Plate 32 |

Brushes came in all sizes, styles, and shapes. Maple, birch, and cherry wood with natural or dyed horsehair were the materials used in fabricating most brushes.

Brush types ranged from shoe brushes, to dusters, to those for sweeping floors. Little documentation exists on this sub-industry. Brushes were made at Mount Lebanon, Shirley, Hancock, and other villages.

| Plate 31 |
Brick dwelling house at Hancock

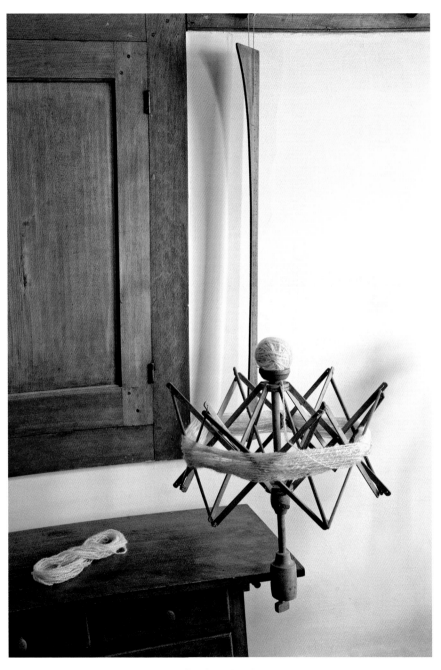

Sometime during the 1840s a new yarn winder, or swift, was developed by Brother Thomas Damon (1819–1880) at the Hancock village. It differed from previous swifts in that it was an umbrella-structured affair, compact and easily clamped to a tabletop, unlike the bulky floor models that were currently in use. The swift, when not in use, collapsed to a vertical post, which further saved on space. The Damon Swift (see Plate 33) became the signature item of merchandise for Hancock. In addition, Brother Damon developed a planing and shaping machine to make the slats for the umbrella device. At least twenty thousand slats a year were first made, enough for 830 swifts to be produced. From the mid-1850s to the 1860s, an average of 920 swifts were made per year and sold for $0.50 apiece wholesale to generate an income of $460 per year. In today's dollars, it translates into approximately $24,000 per year. But it was one of many cottage industries, and the revenues from each added up—so long as there were sufficient members to do the work.

The swift was made usually of maple, with the slats joined together at the middle with a rivet and their ends tied together with string. This construction allowed the umbrella to flex. A yellow paint was often applied to give the swift a clean, colorful look. They came in five sizes, from small to large.

| Plate 33 |
The Damon Swift

Long cloaks (see Plates 34 and 35) originated at the Shaker Canterbury community under eldress Dorothy Durgin (1825–98), after whom the Dorothy cloak was named. A trademark was granted in 1903 for the name "the Dorothy." The long cloak was an important part of the fancy goods business at Mount Lebanon and Hancock. In the 1890s at Mount Lebanon, the Dorothy cloak was made under the direction of sister Clarissa Jacobs (1833–1905); then sister Emma Jane Neale took over around 1900. She immediately filed for a patent, and received one on the long cloak in November 1901 to bolster the newly formed business entity, E. J. Neale and Co. of Mount Lebanon, New York. Similar cloaks were made at the Second Family at Hancock in the 1890s and beyond under the supervision of Eldress Sophia Helfrich.

The cloaks were marketed through catalogues, posters at the village stores (see Plate 37), postcards, and exhibitions in major cities. The cloak was aimed at the well-to-do, and not the average citizen. Cloaks were made from French wool broadcloth and silk

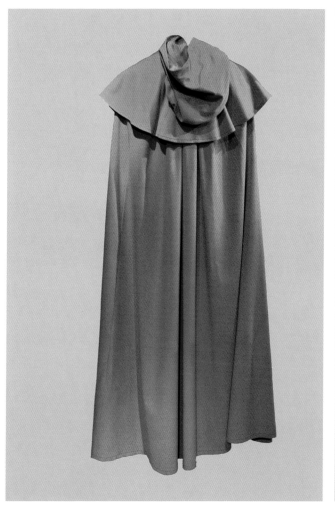

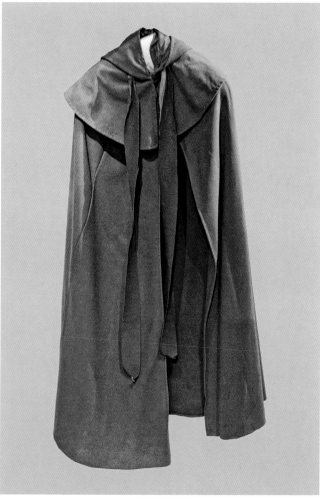

| Plate 34 | Two different cloaks in the Hancock | Plate 35 |
Shaker Village collection

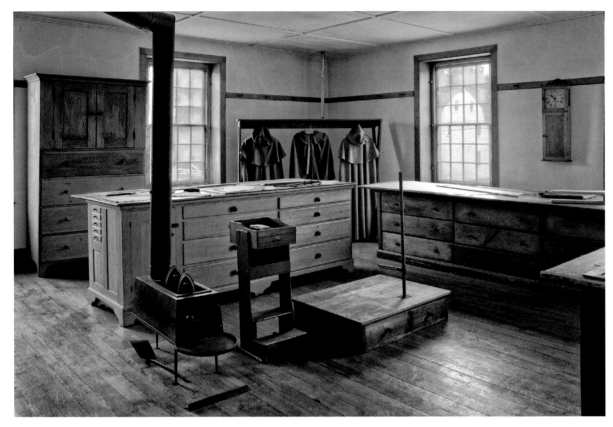

| Plate 36 |

Plate 36 shows the cloak-making room at the Hancock Shaker Village. Cloth was laid out, cut, then assembled. A typical scene is revealed at Mount Lebanon in Plate 38, with sisters involved in cutting, sewing, and fitting. The latter photograph probably was taken in the late 1890s or early 1900s. The two neighbors, Mount Lebanon and Hancock, got into the cloak business as part of their fancy goods business after the Dorothy Cloak was introduced by Canterbury Shaker Dorothy Durgin, in the late 1890s.

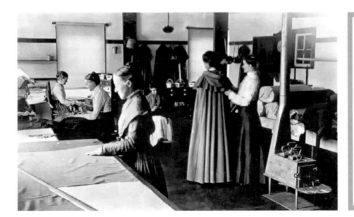

| Plate 37 |

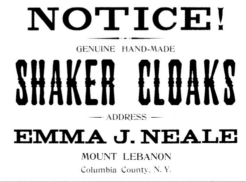

NOTICE!

GENUINE HAND-MADE

SHAKER CLOAKS

— ADDRESS —

EMMA J. NEALE

MOUNT LEBANON
Columbia County, N. Y.

| Plate 38 |

lined. The business at Canterbury lasted until 1942, the one at Hancock lasted until around 1916, and that at Mount Lebanon ended sometime in the late 1930s.

If any one piece of clothing typified a Shaker sister, it was her cotton net cap (see Plate 39). Pictures of Shaker sisters wearing cotton caps were taken right up to the 1960s. Bonnets had a long history with the Shakers. Palm-leaf and straw bonnets were made, worn, and sold from the late 1820s until the Civil War period. The business in bonnet sales was lucrative in the 1830s. Sales of $1,963.71 for 1,866 bonnets sold from April 1836 to June 1837 were recorded by the deaconess at the Church Family at Mount Lebanon. Yet by the Civil War, sales trailed off to less than $50 per annum. In the 1850s and possibly earlier, bonnets of silk, silk chenille, and silk velvet were made for sale. The bonnet shown in Plate 40 is from the Hancock Shaker Village collection. Little is know about prices for the silk bonnets, but the palm-leaf and straw bonnets were sold for around $1 for adult sizes and $0.50 for children's sizes.

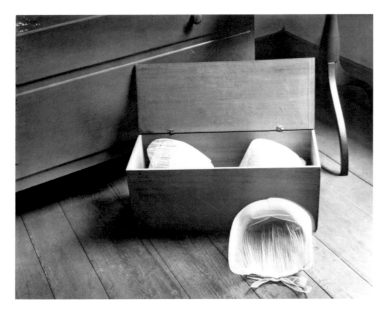

| Plate 39 |

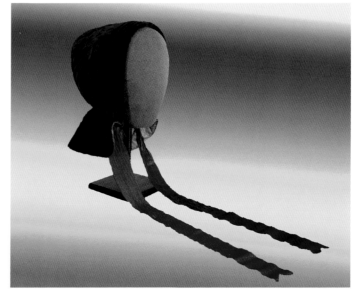

| Plate 40 |

Cotton net caps were pervasive among sisters toward the end of the nineteenth century and well into the twentieth century. They were more sensible than the elaborate silk bonnets often worn by women during this period, and were certainly cooler, whatever time of year.

Another item associated with the Shakers was their oval-shaped boxes. Useful, simple, yet beautiful, these boxes were in keeping with their tenets except for the fact that they were also beautiful. Beauty for its own sake was frowned upon. Superfluities of any kind were disallowed by Millennial Laws of 1821, 1845, and 1861. It wasn't until the 1880s or little earlier that the Shakers began to loosen up, when they started to hang pictures in their rooms, use wallpaper, and use linoleum on floors. They started to adopt Victorian aesthetics, thereby putting on a public face that signaled they were progressive.

David Meacham Jr. launched the oval box industry in the early 1800s at the Second Family at Mount Lebanon. It wasn't until the mid-1830s that specialized machinery was developed: a jigsaw device to cut out the well-recognized fingers, called swallowtails, to form the external joints; a planer to smooth out the maple sides; and a circular saw to cut the tops and bottoms for the boxes. Once the swallowtails were cut out at one end of a strip of maple, the wood was steamed then wrapped and shaped on an oval mold (see plate 41). Finally, the swallowtails were secured with either copper or iron rivets. Next, discs of pine were fitted to the top and bottom to complete the box. The construction was errorless.

Boxes came in various sizes, from No. 1, the largest (fifteen inches) to No. 11, the smallest (one and a half inches). See Plate 42. The enterprise was reasonably prosperous for the Second Family. Even though records are scant, in 1854 there were recorded sales of 840 boxes. Nested box sales were also robust. A full nest of eleven boxes cost $5.00 around 1870 and, of course, prices of individual boxes went by size, for example, No. 6 at $2.00 and No. 11 at $0.75.

Box making at Mount Lebanon went one step further and added a handle to the oval-shaped box (see Plate 43). Carriers, as they came to be called, were either varnished or painted in subdued hues of yellow, blue, or red. They became especially popular when swivel handles became available on all models. Boxes were made at other Shaker villages as well. Very likely thousands upon thousands of oval-shaped boxes were made over the century at Mount Lebanon alone, which ended box making sometime after 1870.

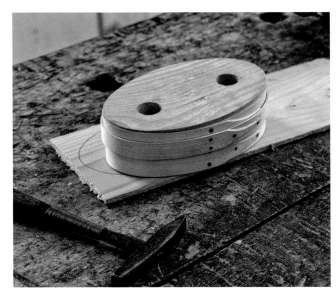

| Plate 41 |

Delmar Wilson at the Shaker Sabbathday Lake Village started to manufacture carrier boxes around 1900. However, a different use for the boxes was hit upon: a sewing box lined with linen. The sisters lined them and tied a ribbon to the box. By the early 1920s, Brother Wilson's output was slightly over 1,000 per year. The carriers were sold at local resorts, by catalogue, and through their own village store at Sabbathday Lake. The woods used by Brother Wilson varied as well: the sides and handles were made mostly from apple wood and sometimes cherry, oak, pine, or maple. Brother Wilson became known as the dean of the carrier makers. The era of genuine Shaker carriers ended in 1961 upon his death.

Although these secondary industries played a vital role in bringing in revenues, mining and agriculture helped carry the families at Hancock into the twentieth century in a somewhat financially stable condition. Sweet corn and potatoes were grown, harvested, and sold from the 1870s

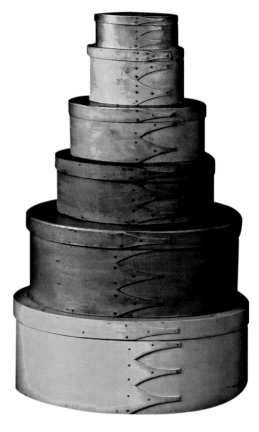

| Plate 42 |

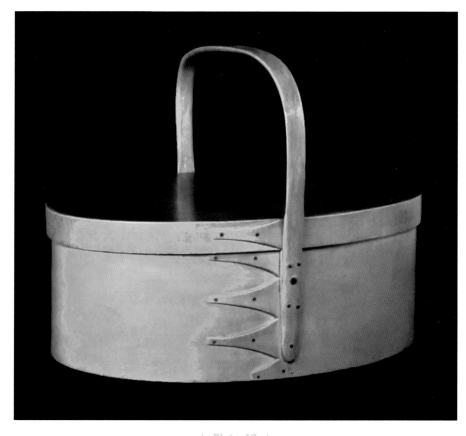

| Plate 43 |

to 1900, enterprises instituted at Hancock by Ira Lawson, a Trustee at the Church Family. He was a bright businessman and oversaw expansion of the grist mill business, made needed land sales at Hancock, and managed the royalties from iron mining at the East Family. Mining at the family ran from the 1850s until February 1896, when water flooded the mine. The mining royalties financed renovation of the dwelling house, construction of a new icehouse and blacksmith shop, construction of an aqueduct to power a churning machine at the sisters' dairy shop, and renovation of the Trustee's house.

However, by the turn of the century, the membership at Hancock had dropped to forty-three, spread among the Church, the Second, and the East families. In August 1911 the latter was dissolved, leaving just two families at Hancock. Still functioning by 1900 were the grist and saw mills, but the Shakers' main agricultural industries were greatly diminished or gone due to the absence of male members and the selling off of land.

Like that at Hancock, Mount Lebanon's membership was in rapid decline. By 1900 it still had some revenue from its herbal medicines and chair businesses, but, like Hancock, it saw its agricultural industry decline to a shadow of its former self. The sales of swifts, homemade foodstuffs, cloaks, sweets, postcards, and small handicrafts were now the principal incomes in addition to that coming from the mills.

ON JUNE 29, 1960, a meeting of the central ministry composed of Eldresses Emma B. King and Ida Crook of Canterbury and Gertrude M. Soule of Sabbathday Lake voted to sell the land and buildings at Hancock for $125,000 to Shaker Community Inc. (SCI), a non-profit organization led by Amy Bess Miller. The closing of the sale took place on October 15, 1960.

The sale was most fortuitous to preserving and restoring Hancock, thereafter called the Hancock Shaker Village. At the time of the sale Hancock consisted of 974 acres and twenty-one buildings (eleven principal ones and ten secondary). Seventeen of these original buildings—including barns, shops, and the brick dwelling house—were in reasonably good shape, while others would require extensive work.

SCI's principal objective was to recreate Hancock as it would have been in its classical period, to the greatest extent possible. From 1870 to the 1950s much had been done in incorporating many worldly superfluities into Shaker buildings; for example, wallpaper, painting, woodwork, and hanging pictures in contradiction of the 1821 Millennial Laws. Authenticity was called for in the restoration and reconstruction activities. Thirteen buildings were restored, with one—the school—reconstructed. The dates of restoration were:

Building	Date	Building	Date
Dwelling House	1960–61	Ice House	1970
Meeting House	1961–62	Tannery	1972–73
Sisters' Dairy & Weave Shop	1961	Horse Barn	1974
Brethren's Shop	1961 & 1973	Hired Men's Shop	1976–77
Laundry and Machine Shop	1967	Barn Complex	1980–81
Ministry Shop	1968	School House	1978
Round Stone Barn	1968		

It took more than twenty years to complete the restoration. The barn complex was the last to be worked on, in the early 1980s. The work done by SCI was nothing short of Herculean in scope. It took considerable dedication and hard work by the trustees, the staff, and the outside donors to create an authentic outdoor museum. Probably the two most involved and intensive restorations were those of the meeting house and the Round Stone Barn.

Master Shaker builder Moses Johnson built eleven gambrel-roofed meeting houses throughout the Shaker communities during the late eighteenth century. His 1786 meeting house at Hancock was dismantled in 1938, most likely to reduce property taxes paid by the society. By luck, it came to the attention of SCI in the summer of 1961 that the Shirley community's meeting house, now owned by the State of Massachusetts, was slated to be torn down even though it was in good condition. For the price of $1, the SCI purchased the Shirley meeting house from the state. Early in 1962 the 32-by-44-foot house was cut into nine sections and each section was hauled separately to the Hancock Shaker Village from Shirley, a distance of 122 miles. Twenty-one granite foundation stones, each weighing two tons, were also carried off to Hancock. By the spring of 1963, the meeting house was completely re-erected at the same site as the original Hancock meeting house thanks to the financial support of Mrs. Bruce Sanborn, a Hancock Shaker Village benefactor.

No building at Hancock received more attention than the Round Stone Barn. It was the first such barn built by Shakers, dating back to 1826. However, by 1963 the cracks in the walls, with a resultant tilt of the walls, were enough to close the barn to visitors. Imminent collapse was a real possibility (see Plate 45). Through the generosity of the

Beinecke family of Great Barrington, Massachusetts, funding was secured and work was started in February 1968 to rebuild the Round Stone Barn, stone by stone. The Fuller Construction Company, in charge of the restoration, agreed to do the job at cost. By September 1968, the restoration was completed through the efforts of thirty-six construction workers and engineers.

The present layout of Hancock Shaker Village can be seen in Plate 44. There are twenty-three buildings, small and large. If one compares the 1820 map (Plate 1) to it, one can see that the ministry, the school, the meeting house, and the laundry and machine shop are located very close to the sites in the 1820 map except for relocation of the shop in 1829. SCI did an impressive job of restoration and relocation of buildings given the dearth of architectural/structural maps for Hancock.

Of immediate concern after the purchase of Hancock was how to fill, at least partially, the mostly empty buildings with Shaker furniture and relevant artifacts, since the Village was to be opened to the public in 1961. With the declining membership over the nineteenth and twentieth centuries came lack of income to sustain Hancock, so the trustees had resorted to selling off furniture and other artifacts.

There was an outpouring of donations, and many purchases by SCI in the first ten years to help fill the many buildings. Edward and Faith Andrews donated much of and sold some of their fifty-year-old Shaker collection to SCI; Canterbury Shaker Village sold pieces of furniture to SCI; others would donate artifacts, manuscripts and financial records of Hancock, and Shaker farm implements and tools. Over the years even more items came to Hancock Shaker Village so that today it's a repository of the Shaker past. From its architectural structures to the multitude of Shaker artifacts and furniture pieces (which number around 22,000 objects), visiting the Hancock Shaker Village is like going back 175 years or more into a decidedly different world: the world of the Shakers.

We will make this visual journey into the past via the present Hancock Shaker Village and correlate, when possible, similar imagery at Mount Lebanon. First let's look at what the Shakers at Hancock must have experienced at their home in those early morning hours after sunrise. Next, let's look at their daily work activities, then their communal living and religious activities. Finally, we will focus on several major Shaker voices, speaking to the world in the late nineteenth and early twentieth centuries. These individuals, as we will see, helped to communicate who the progressive Shakers were and what beliefs they held.

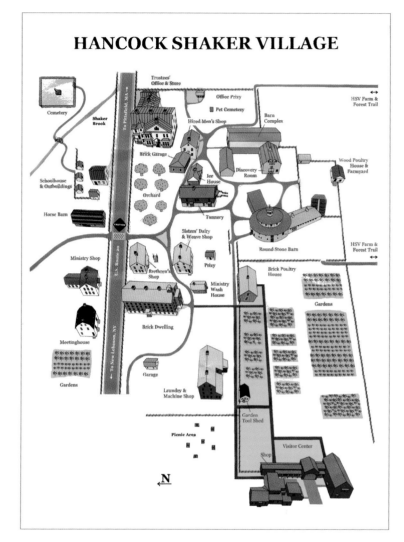

| Plate 44 |
Current Hancock Shaker Village

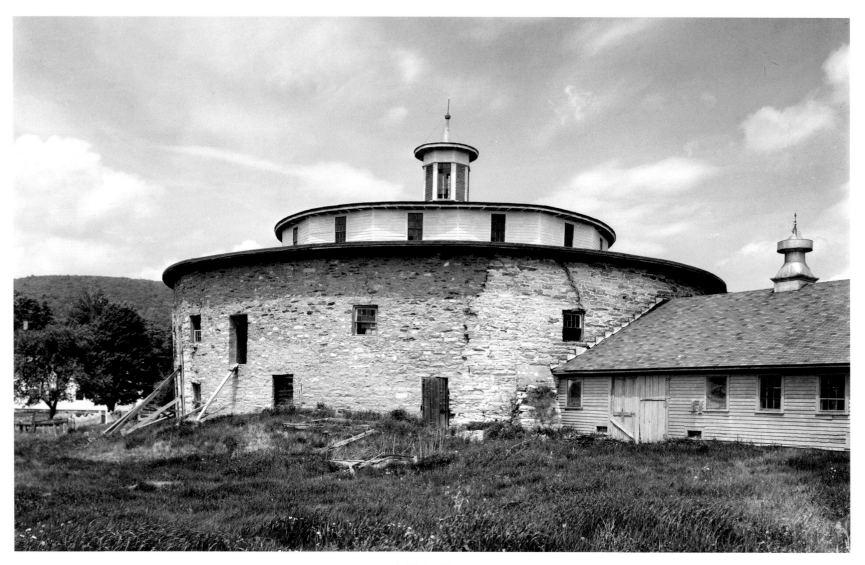

| Plate 45 |

EARLY MORNING AT HANCOCK

PRIOR TO 1850, the Shakers were up and about at 4:30 a.m. in the summer and 5:00 a.m. in the winter. An hour was set aside to clean up their rooms, do their early morning chores (indoors and outdoors), a little praying, and then breakfast at 5:30 a.m. (6:00 a.m. in the winter). When strolling through the village just after sunrise, one can sense a sort of harmony and order to the way buildings are aligned and grouped and the way all are connected by pathways. Even now in the twenty-first century, everything seems to have a place and there is a place for everything: the buildings, the fences, and the fields. Plates 46–51 touch upon scenes that the Shakers would have experienced on a daily basis, in the 1840s for example—they evoke a world seemingly at peace and a strong sense of village permanency. It's understandable why Hancock was called the City of Peace. That spiritual name was given to Hancock during the Era of Manifestations or Mother Ann's Work, a spiritualistic outpouring that started in 1837 and lasted sixteen or so years.

One can only imagine what sort of intimate feelings of home the Shakers must have experienced each day as they saw a village which, in their minds, would last. Their buildings contained no distracting elements that would take away from the quiet simplicity of their design. The absence of pretense or adornments in their architectural features fell in line with Shakers' striving for simplicity and humility in both their craftsmanship and their lifestyle. Beauty was something inherent in a work that met the needs of a life directed by contemplation, the correctness of hand and heart, hands to work and heart to God. What was done was sacred, and so too was their village. They were trying to build a heaven on earth, and each village was meant to embody that goal.

| Plate 46 |

| Plate 47 |

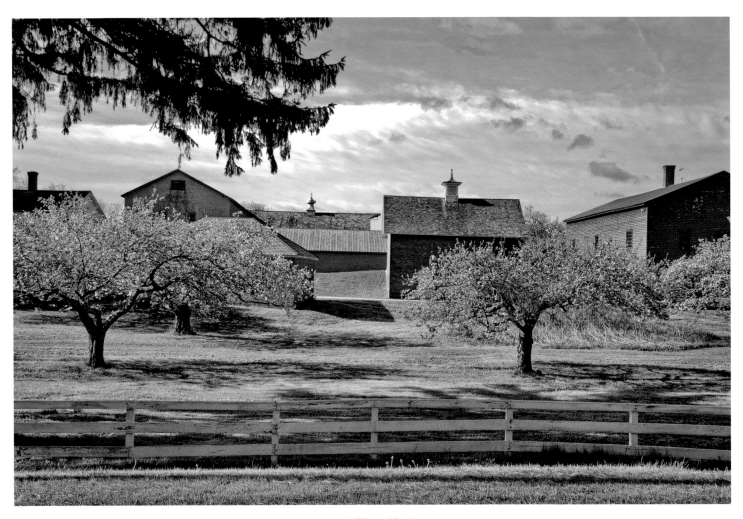

| Plate 48 |

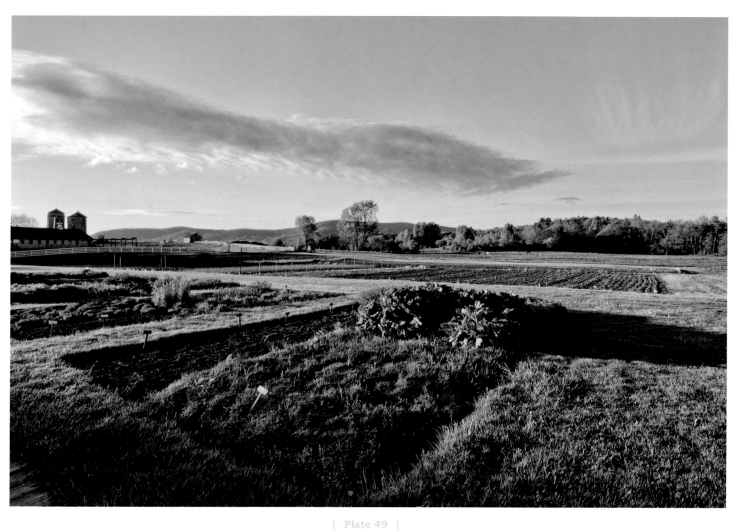

| Plate 49 |

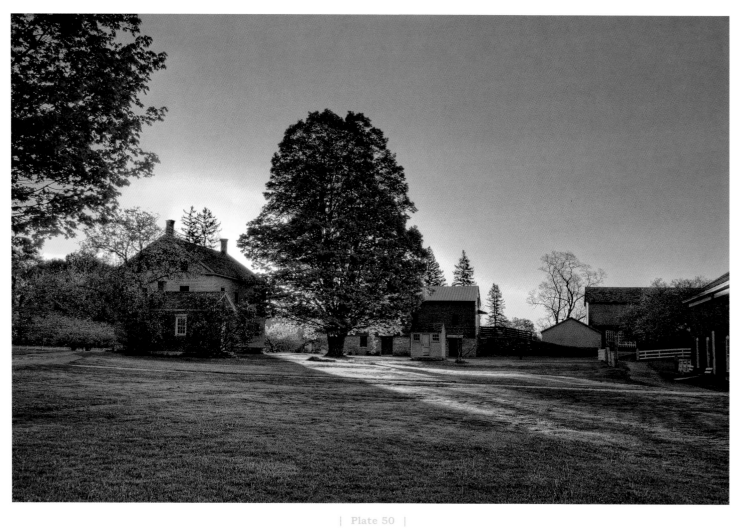

| Plate 50 |

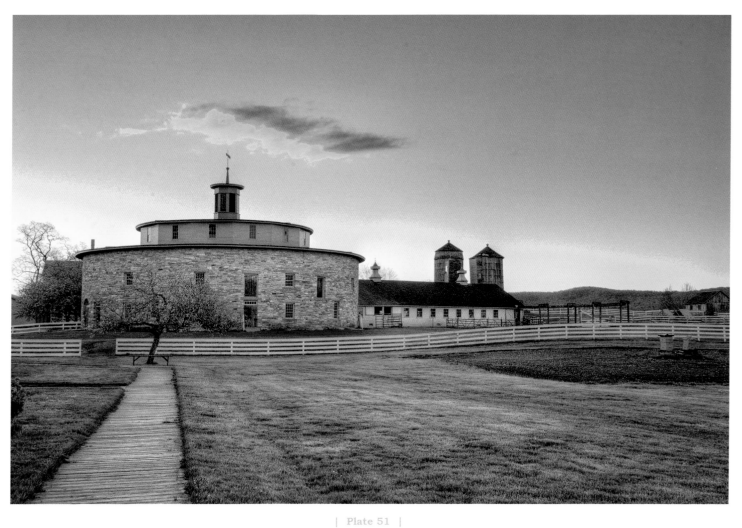

| Plate 51 |

THROUGH MOST OF THE 1800s, living in a Shaker village was similar to being on an island. Each family in the community was expected to be as self-sufficient as possible given the natural and man-made resources at their disposal. Yet, if in trouble, a family was helped by other families. Trade outside the village was handled through appointed conduits: the Shaker deacons and trustees of each family. The average believer's social and work activities were restricted within the boundaries of the family holdings. To leave the village, to read about the outside world, or to communicate with others outside the family was only allowed with permission of the family elders.

These temporal rules were coupled with numerous rules regarding interactions between the sexes to ensure celibacy and prevent intimacy. Yet, the temporal and spiritual bonds that developed among the Shakers created a very satisfying way of life during the nineteenth century; yes, there were apostates, but they were in the minority among those who, once converted to Shakerism, remained as Shakers. In that sequestered world of the Shakers, equality, fraternity, and economic prosperity among the believers were realized. They attributed their success to their spiritual endeavors and beliefs. Most likely it was due to an equal combination of industry and religion, but their survival depended strictly on industry.

The daily activities of Shaker life centered on work, which was then followed by social and religious activities. Everyone was expected to work: the common believers, the trustees, the deacons, members of the ministry, and children when not in school. There were defined categories of work by gender.

The sisters' work included cooking, sewing, spinning, gardening, cloth making and mending, making clothing, carpet making, cleaning, laundering, product packaging, cheese making, fancy goods making, and more.

The brethren's work included farming, grist and lumber mills, tanning, cabinet and chair making, carpentry, plumbing, shoemaking, masonry, shingle making, tinware making, wooden box fabricating, leather goods fabricating, blacksmithing, and others.

The social activities took place principally within the dwelling house, which was not just for sleeping; dining and both religious and non-religious meetings took place there during the week. Visiting guests were occasionally entertained at the house but mainly at the trustee's office. On the other hand, the meeting house alone was used for religious gatherings, dancing and singing, and the living quarters of the ministry. Through past photographs, we will now look at the various activities at Hancock and, when relevant, similar ones at Mount Lebanon.

If anyone could be called a mechanic, it was the Shaker blacksmith. He made door latches, knife blades, shears, hoes, iron neck-yokes, cut nails, axes, keys, plow-irons, ox yokes, chest hinges, and a multitude of different tools. Early in the 1800s the smithy produced considerable revenue for the struggling villages of Mount Lebanon and Hancock via business from outside farmers. Plates 52 and 53 depict the trip hammer and forge at the north end of the tannery at Hancock. It was built around 1875. The trip hammer was driven by a belt system turned by a water turbine. The large bellow shown in Plate 53 fired the coals in the forge. It was hand operated using a lever system similar to the large bellows shown in Plates 54 and 56 at the North Family forge at Mount Lebanon.

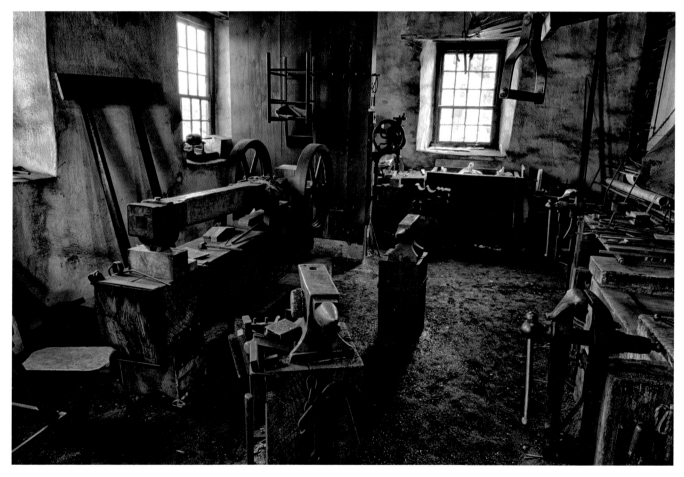

| Plate 52 |
Blacksmith forge at Hancock Shaker Village

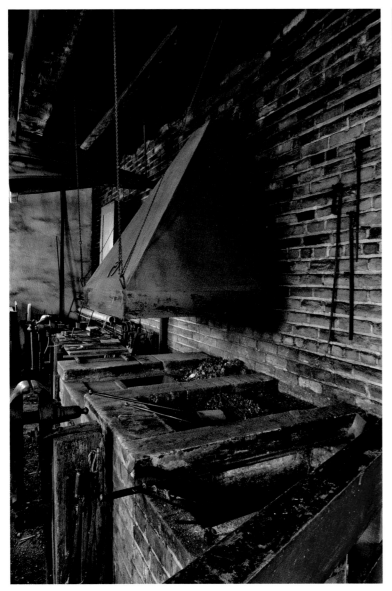

| Plate 53 |

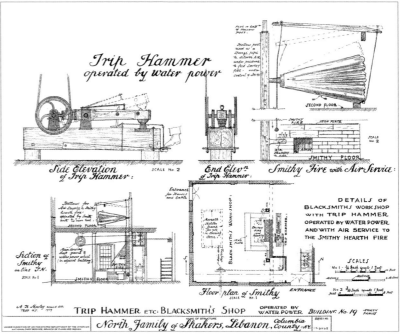

| Plate 54 |

Note in Plate 56 that the neck of the bellows hooks into a pipe that continues down through the ceiling and empties into the base of the forge (see Plate 55). The smithy worked a handle to compress the bellows with a downward stroke to expel the air. A schematic of the trip hammer and bellows (Plate 54) was done by A. J. Mosley in his 1939 survey of Mount Lebanon.

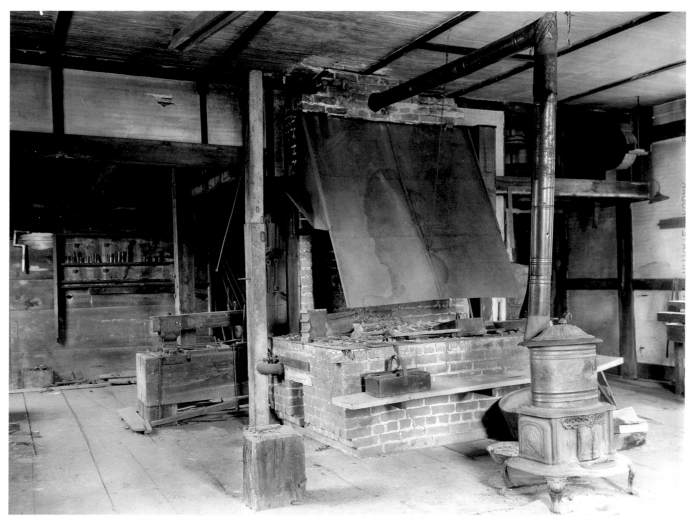

| Plate 55 |
Blacksmith forge at the North Family at Mount Lebanon

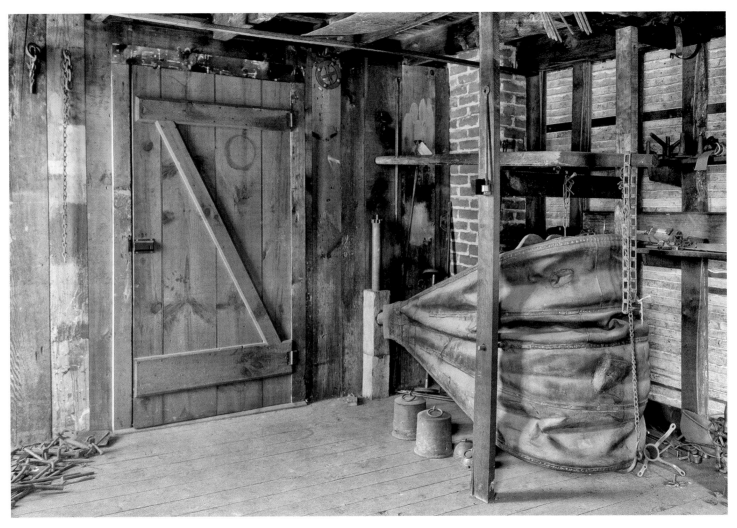

| Plate 56 |
Bellows at Blacksmith shop at North Family at Mount Lebanon

Plate 57 shows the 1835 tannery at Hancock, and Plate 58 shows the tannery at the Church Family at Mount Lebanon, built around 1800. At Mount Lebanon tanning was an active occupation from 1810 to 1875. Thousands and thousands of various hides (calf, cow, sheep, horse, lamb, deer, and others) were processed at both Hancock and Mount Lebanon.

Waterpower-driven grinders of hemlock bark, a primary dye source, were installed, and by 1850 cold dyeing vats were replaced with heated ones to speed up the dyeing process.

Around 1875, the competition from commercial tanners brought an end to tanning at Hancock and Mount Lebanon as well as in other villages.

The second floor of the tannery at Hancock was turned into a carpenter's shop and the lower level into a cider mill with the closure of the tannery. The large door (Plate 59) is what remains of the cider mill and tannery entrance, which is located on the right side of the building.

The leather from the tannery operation went to make such items as shoes for the Shakers, saddles, bridles, harnesses, and even mittens.

One can't help but associate the Shakers with their ubiquitous pegboards, from which they hung chairs and brooms when they were not in use. The pegs were screwed into the board, so it's not surprising to find in the carpentry shop at the tannery a treading machine for pegs (see Plate 60). Right of center sits the peg with its tip housed in a small rectangular box. Cutting blades inside the box create the tread when one cranks the handle on the left of the device. There are two adjusting screws to adjust the depth and pitch of the tread.

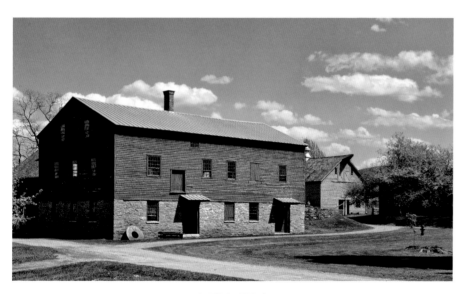

| Plate 57 |
Tannery at Hancock Shaker Village

| Plate 58 |
Tannery at the Church Family at Mount Lebanon

| Plate 59 |
Lower level door of the Tannery at Hancock

It's not every day that one sees a wooden vise like the one shown here in Plate 61. It was made at Mount Lebanon in the early 1800s, and was later supplanted after 1830 by British-made iron vises.

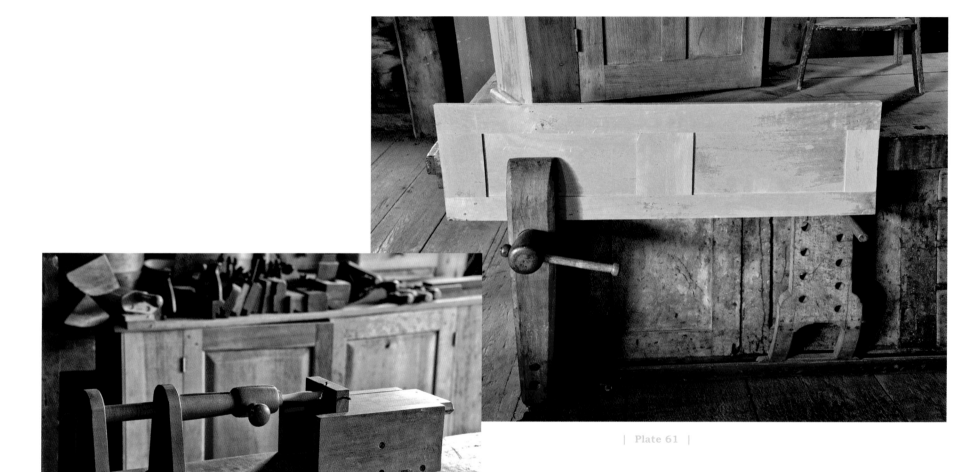

| Plate 61 |

| Plate 60 |

58

Normally each family had a cobbler. Making shoes for internal use was the primary job of the cobbler, who typically worked in the early morning and after sunset—the times when the believers were not working at their own jobs. He made a wooden last for every family member. Cloth shoes with leather soles were made for believers, as well as all-leather boots and shoes. This activity continued well into the nineteenth century.

According to Millennial laws, it was contrary to order to have a left and right shoe made. So each shoe in a pair was identical.

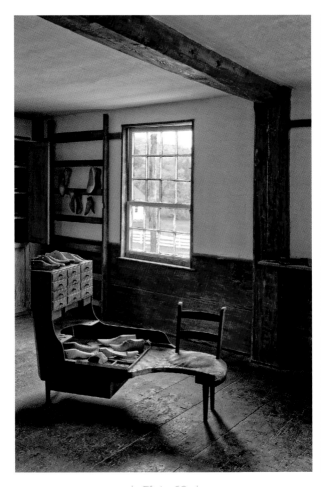

| Plate 62 |

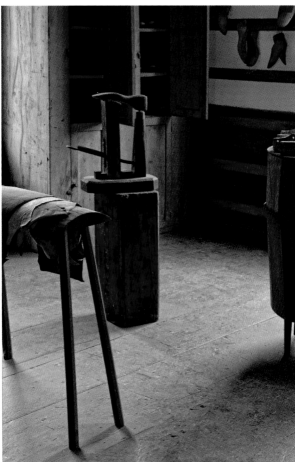

| Plate 63 |

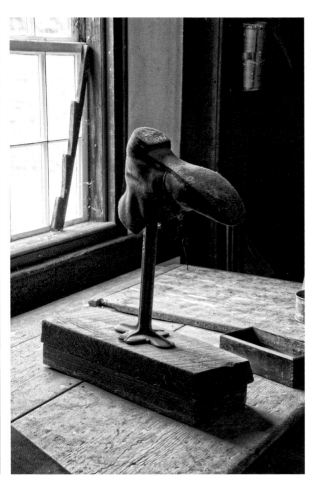

| Plate 64 |

Every family had a Brethren's Shop. What differed from family to family was the size and construction materials used for the shop; Plate 65 shows the 1813 Church Family Brethren's Shop in the foreground while Plate 66 is a frontal view of the 1829 North Family's Brethren's Shop at Mount Lebanon, which is currently being restored. The latter is a 17,000-square-foot, three-story brick building with an enormous attic, built at a prosperous and optimistic time for the Shakers.

At Hancock the brothers made brooms, chairs solely for internal use (see Plates 67 and 68), oval boxes (see Plate 69), shoes, hats, wooden dippers, cheese hoops and dry measuring containers, carpet beaters, seed boxes, and other items. Some items (e.g., oval boxes) were sold to the world. Similar work activities took place at Mount Lebanon mainly during the nineteenth century.

Plate 70 shows a carpentry shop at a Brethren's Shop at Mount Lebanon. The stacked circular forms could be sieves or dry weight containers before handles were attached.

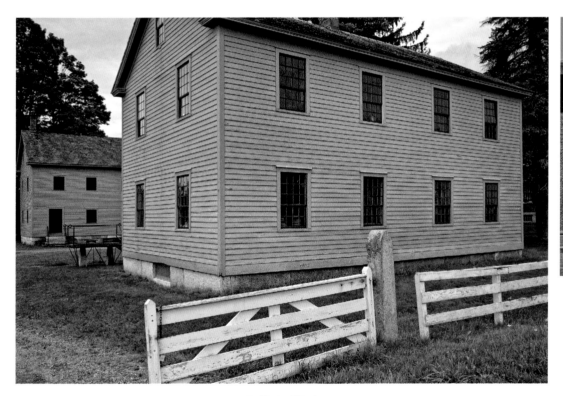

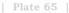

| Plate 65 |

| Plate 66 |

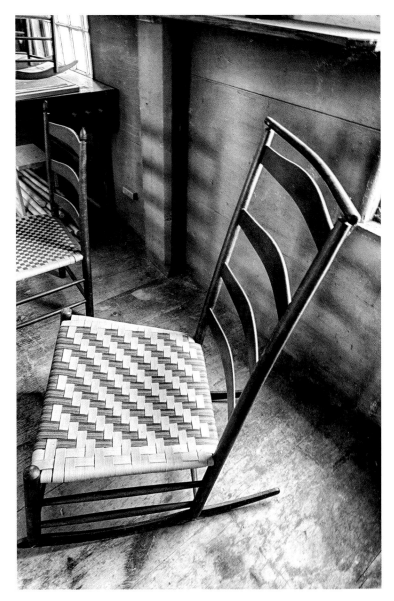

| Plate 67 |

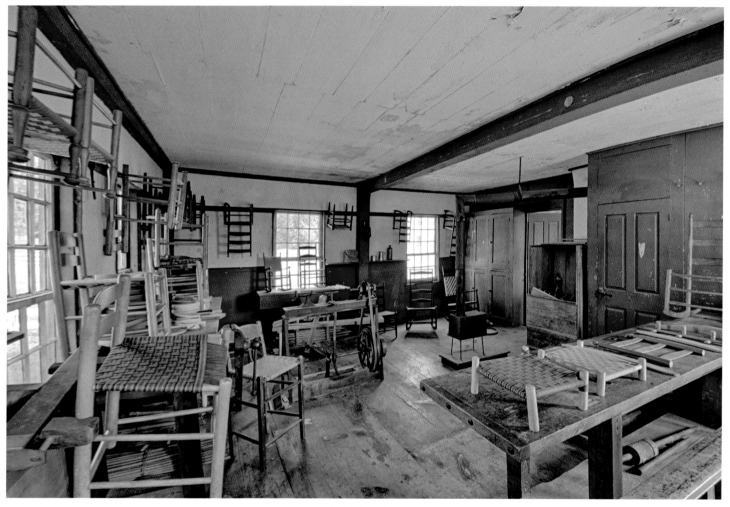

| Plate 68 |

62

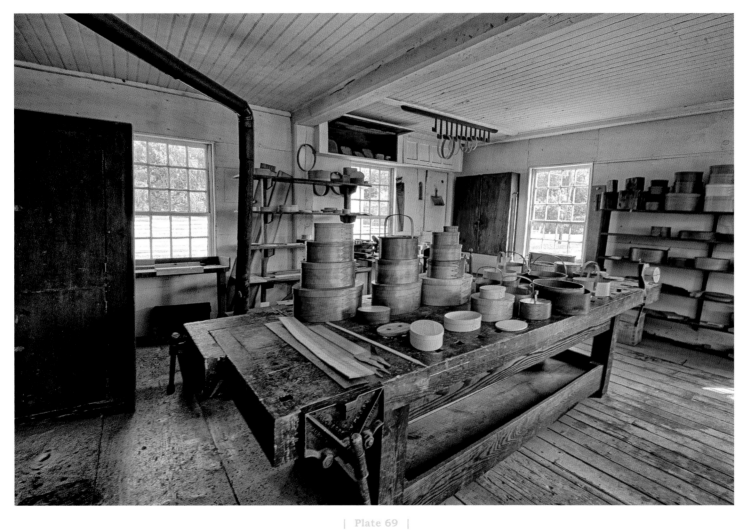

| Plate 69 |

As a side note, the last male Shaker at Hancock, brother Ricardo Belden, had living quarters at the Brethren's Shop from the 1930s to the late 1950s; he died at age eighty-nine on December 2, 1958, and was buried at the Enfield, Connecticut, Shaker cemetery. He was originally from the Enfield community.

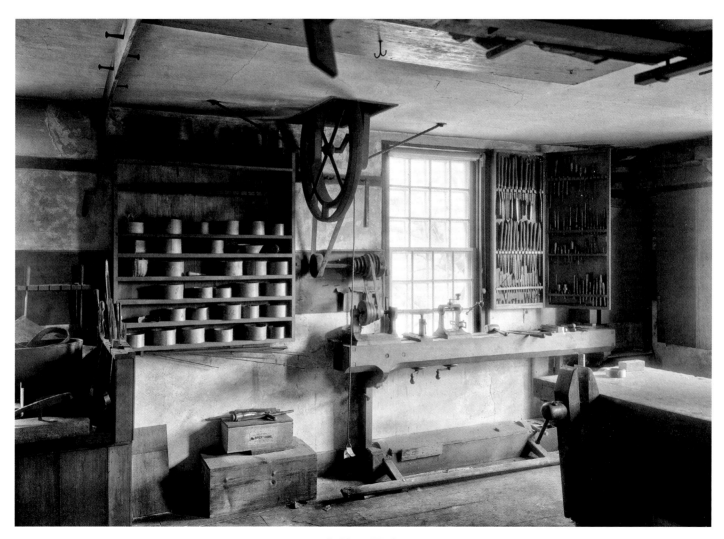

| Plate 70 |

Shakers were always enlarging buildings when the need came to expand. Such is the case with the two-storied Sisters' Dairy and Weave Shop; it was once the one-story dairy shop shown in the 1820 map of Hancock (see Plate 1). The Sisters' Dairy and Weave Shop is one of the oldest structures at Hancock, dating back to around 1800 or earlier.

The dairy shop is a short distance from the Round Stone Barn with its attached cattle pen. The brethren would milk the cows in the morning and would deliver the milk in jugs to the now-long-gone back porch of the dairy shop. The sisters then would place the jugs in a stone cooling basin (see Plate 71). A natural spring under the shop was used as a coolant. Such a clever arrangement is just another example of how Shakers used what nature provided.

With fifty-two cattle the milk output could range from 260 to 416 gallons per day (about five to eight gallons per cow per day). The dairy industry was part of Hancock's economic base, with milk and cheese products sold to the outside world.

Mention of the dairy business, as well as a window into the sad decline of the Shakers, can be found in a note by Eva Libbey published in the December 1899 issue of the *Shaker Manifesto*. This was the last publication of the *Shaker Manifesto,* which was a monthly newsletter sent to the Shaker communities. The dairy industry at the Alfred, Maine, community was as integral a part of that community's economic base as it was at Hancock.

West Pittsfield, Mass.

Sept. 1893

Another important item in June no. by Sister Amelia Calver, in which she notes the exhortation by Elder Daniel Offord regarding the care of our premises, is of moment. Were such wise counsels heeded by all, what a wealth of beauty might be added to our Zion homes.

Br. Ira Lawson continues his efforts to make improvements. Is laying a line of ten inch earthen pipes a distance of over four hundred feet, to conduct water from the laundry and machine shop, to another shop.

Has also placed two hydrants along the line to be used in case of accident by fire, and will attach two garden hydrants. A motor, the (Maelstorm), is to be placed in the dairy for churning purposes.

The ancient method of hand churning will soon be a thing of the past with us, as it has long been with most of our communities.

From *The Manifesto,* October 1893

Yarn spinning (see Plate 74) was taken up early on by the Shaker sisters at all Shaker communities, as was weaving on looms (see Plates 75 and 76). The "homespun" industries were finally organized under one roof in most families by the 1830s, as in the Dairy and Weave Shop at Hancock. Weaving materials were diverse: cotton, wool, linen, and blends of cotton and wool. Cloth material was used to make various frocks for work, trousers, shirts, habits, and various other clothing, cotton and woolen blankets, and cotton sheets. Tens of thousands of yards of various cloths were made at Hancock and Mount Lebanon. It wasn't until around 1853 that the Shakers started to buy commercial mill cloth, because it was supposedly less expensive to purchase than to make. A comment by F. W. Evans, a major Shaker voice in the latter 1800s, is worth noting.

Competition from the outside world didn't quite eliminate weaving. Chair shag mats, carpets, cotton handkerchiefs, bed spreads and other fabric based items sold in the village stores kept the weaving looms active into the twentieth century at Hancock, Mount Lebanon, and at other Shaker communities.[12]

Alfred, Me

Nov. 1899.

The fall months keep us busy with their various duties. We have no place for drones, "Hands to work and hearts to God," is our motto. We have just stored twenty-two tons of grain in our cow barn. We are getting sixty-four gallons of milk a day, two thirds of which is shipped to Boston. Have a good stock of cattle and have raised twenty-four calves this season.

The fall term of school has closed after a successful season of ten weeks. Number of scholars, fifteen.

During the past month the angel of death has made us a call and taken our Brother, Frank Libbey: a faithful worker in the interests of Zion. It reminds us that this is no continuing city. The present is ours the future we know not of, so we will strive to do what good we can and be working for those treasures which are immortal and perish not.

In parting with THE MANIFESTO we feel that we are parting with an old friend. We hope that some time in the future we can welcome it again to our home.

Eva M. Libbey[11]

| Plate 71 |

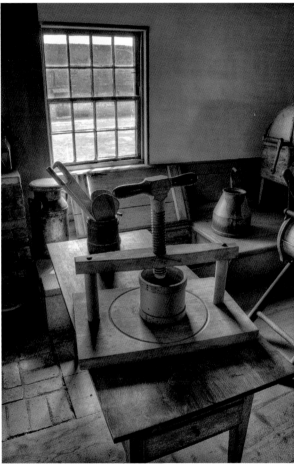

| Plate 72 |

Sisters' Dairy Shop at Hancock Shaker Village

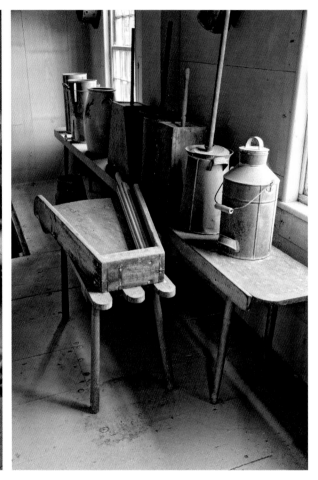

| Plate 73 |

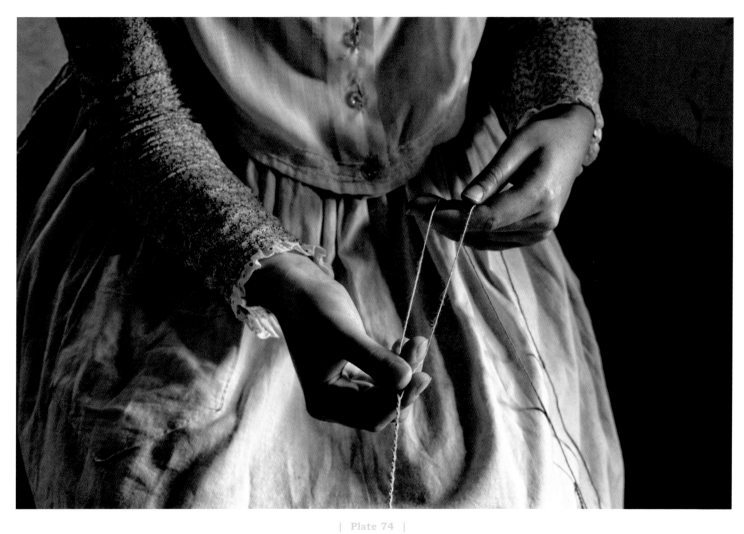

| Plate 74 |

68

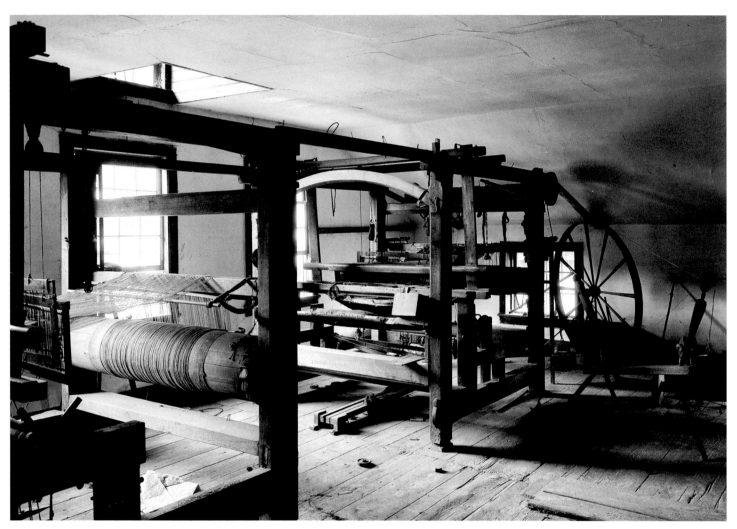

Weaving looms at Mount Lebanon North Family

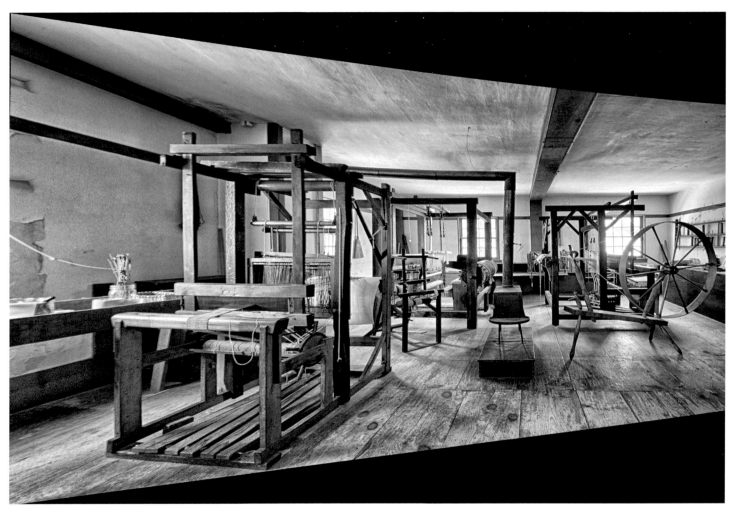

| Plate 76 |
Weaving looms at the Dairy and Weave Shop at
Hancock Shaker Village

In Plate 77 the Laundry and Machine Shop is shown in a west-to-east orientation going from left to right. It is probably the oldest structure at Hancock, with the western section thought to be the original Goodrich farmhouse built prior to 1790, the date of Hancock's organization. In 1817 an underground aqueduct brought water down to turn a twenty-foot-diameter waterwheel to power the machinery and laundry. The same sort of water hydraulics was used at Mount Lebanon, but more extensively. Then, by 1829, the shop was moved to its current location to make way for the new dwelling house. The next innovation was installation of a cast-iron water turbine in 1859, under the guidance of elder Thomas Damon, it being more efficient than a waterwheel. The Shakers always adopted the latest technology if it proved to increase the efficiency of a manufacturing process or reduce the work load, or both.

Attending to the laundry at Hancock was a labor-intensive effort done mostly by the sisters. By 1830 there were close to one hundred believers in the Church Family. Their towels, clothing, bed and pillow sheets, socks, and undergarments all needed to be washed and most needed ironing; it was not a trivial task.

Plate 78 shows the 1967 restored laundry washroom as it likely would have appeared prior to 1860. Much of the washing was done by hand, with hot water supplied by pots heated in the fireplace, while washing and rinsing was done in the scattered tubs sitting on the marble floor. A rope-pulley system brought the washed clothes to the second floor to be wrung out, hung, and dried. Over time the laundry would undergo a transition from hand washing to a water-powered washing machine.

Note the addition of a cylindrical, powered washing machine in the background in Plate 79, the extensive use of plumbing to carry water to different tubs, and the lack of the fireplace in this 1931 scene. Although not visible, there was very likely a boiler to heat water just as there was at Mount Lebanon. One constant in the washroom at Hancock was the marble floor, which remained for a period of close to 200 years.

Plate 80 pictures the rudimentary pulley-system and sheets hanging on rafters designed for just that purpose—drying items of one form or another. Once things were dried, they went down a chute, ending up in a catch basket on the first floor, and then were ironed in a room on the west side of the building. Plates 81, 82, and 83 are images of the ironing room at the Laundry and Machine Shop at Hancock. Plate 83, a photo taken in 1931, demonstrates how Shakers handled the problem of having to wait all the time for irons to heat up: they created a stove to heat multiple irons. Also note in Plate 83 the use of large and small irons. The larger ones probably were used on such items as bed sheets, and the smaller on all sorts of clothing.

Compared to the 1840s at Hancock, their neighbors at Mount Lebanon did things a little differently in the 1920s and 1930s. At the North Family the laundry was done at the wash-house. Boilers heated the water, cylindrical washing machines did the washing, and special pull-out racks (see Plate 84) were used to dry the items. The racks pulled out from the wall onto floor runners, and slid back into the wall when not in use. Plate 85 depicts five sisters, two young girls, and one brother in an ironing room at Mount Lebanon. Note the conical heating stove on the far left. Most interesting is what the brother in the background is doing, He is using, for the sake of a better name, a cloth press as shown in Plate 86. Articles were placed between boards and the stack of boards was compressed by a ratchet arrangement to flatten out the items; manpower and a little physics made it work. Also, at pressing time zinc chloride was applied to clothing to make it resistant to wrinkling and water, a Shaker innovation.

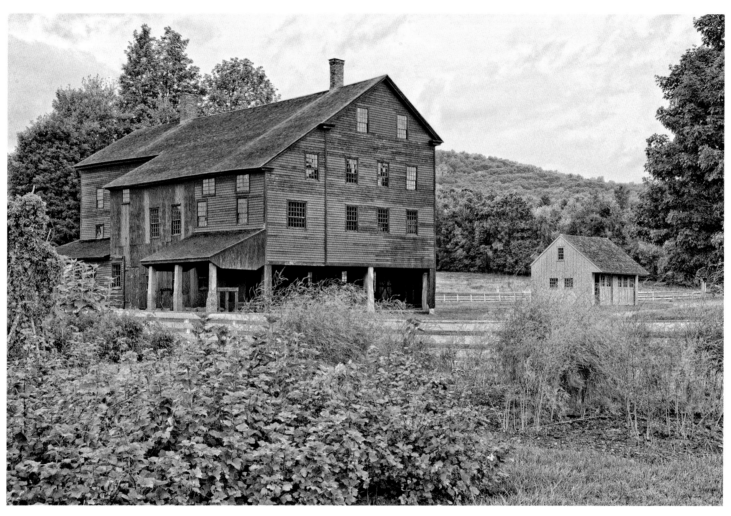

| Plate 77 |
Laundry and Machine Shop at Hancock Shaker Village

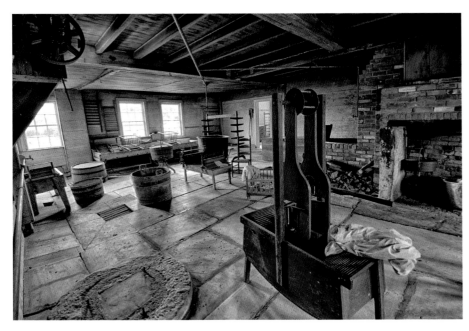

| Plate 78 |

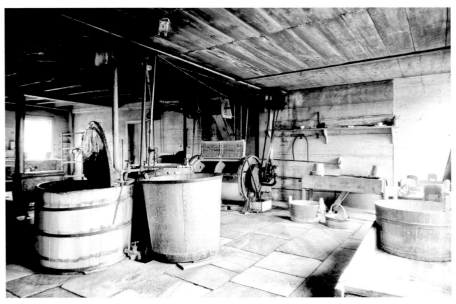

| Plate 79 |

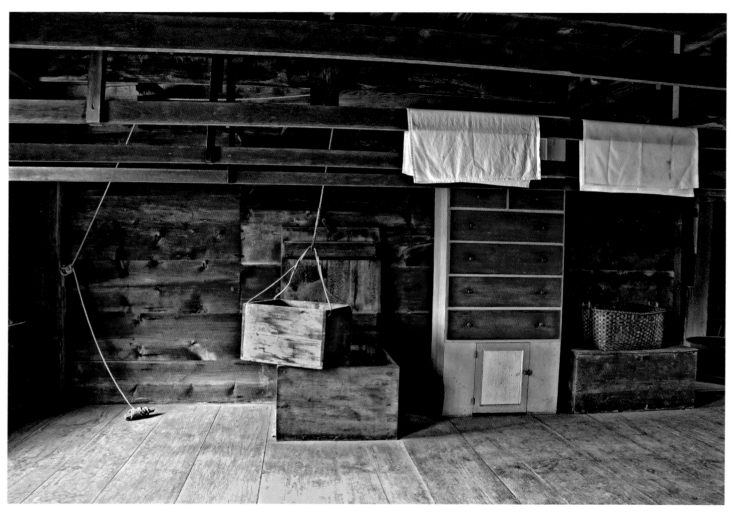

| Plate 80 |
Second-floor drying room at Hancock Shaker Village

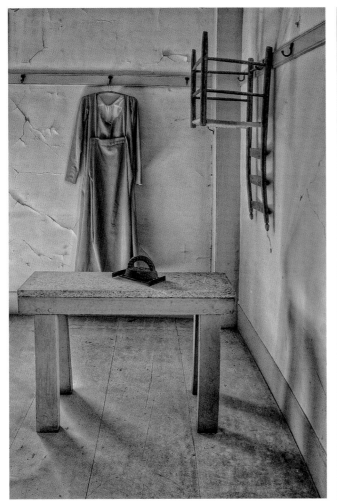

| Plate 81 |

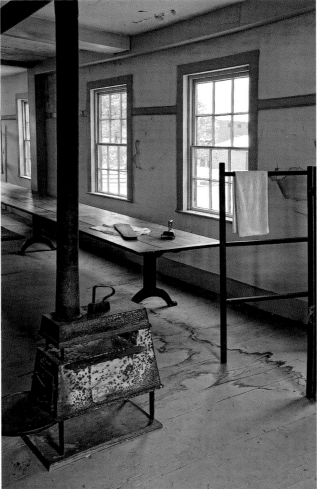

| Plate 82 |

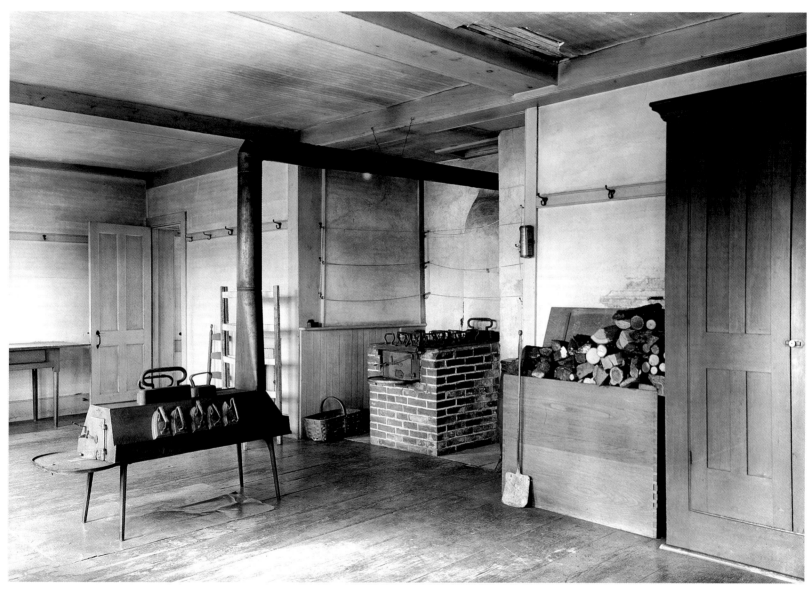

| Plate 83 |

Ironing room at Hancock's Laundry and Machine Shop

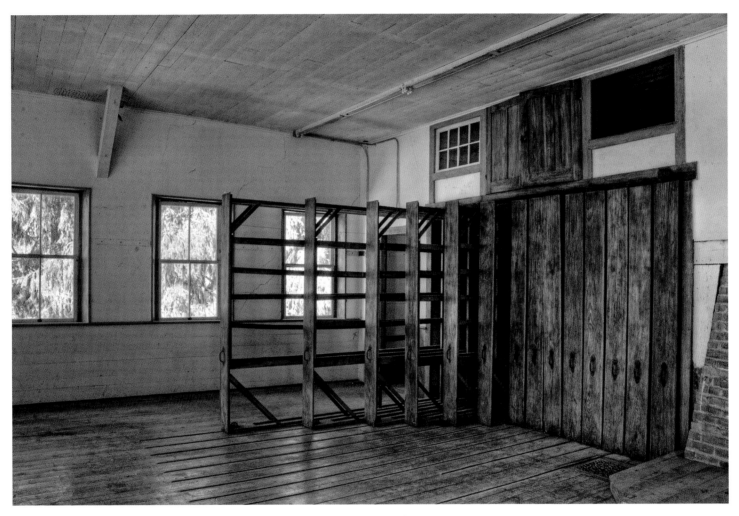

| Plate 84 |
Drying racks at the North Family's wash-house
at Mount Lebanon

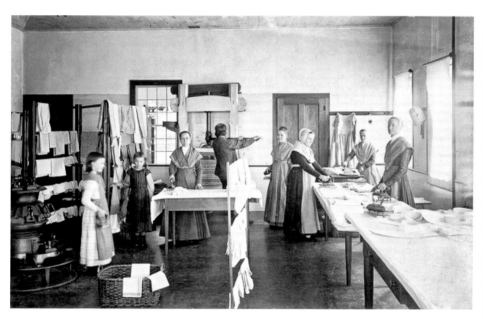

| Plate 85 |

| Plate 86 |

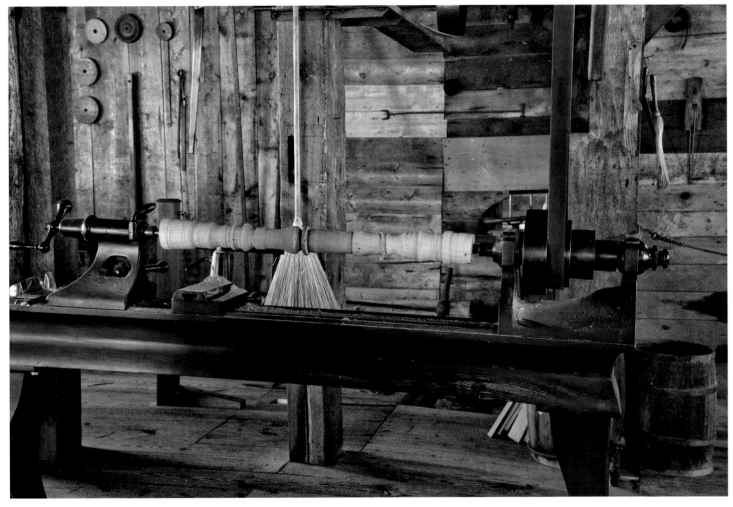

The machine shop occupied the first floor of the east wing of the building. Belt-driven machinery was powered by a water turbine identical to the one of 1859. It was recast in the 1990s. The machine shop was used for woodworking. Plates 87 and 88 provide a glimpse at the shop's associated machinery.

| Plate 87 |
Woodworking lathe, east section of Laundry and
Machine Shop at Hancock Shaker Village

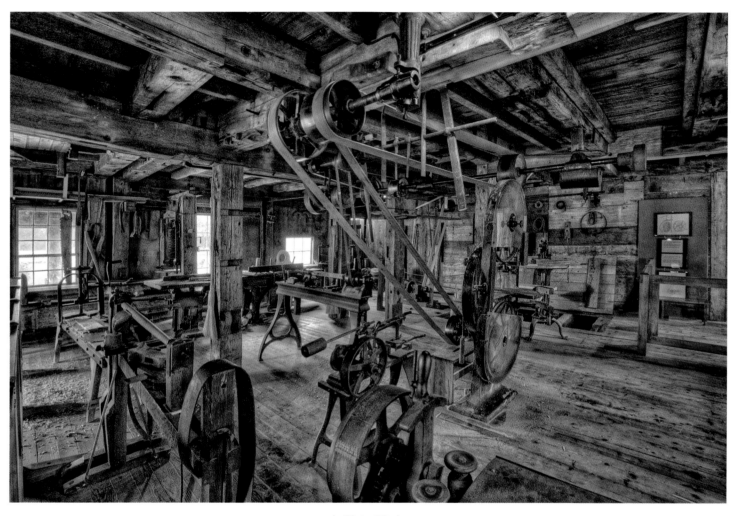

First floor, east side of Laundry and Machine Shop at
Hancock Shaker Village

When it comes to ministries, the Hancock and Mount Lebanon communities were quite different. The former, during its first hundred years, was a bishopric which handled the ministerial affairs for the Hancock, the Enfield, Connecticut, and the Tyringham, Massachusetts communities. Meanwhile, Mount Lebanon was the central ministry for all Shaker villages—the ultimate authority on both spiritual and temporal matters.

Plate 89 gives a view of the rather modest, wooden ministry shop at Hancock. Compare it to the 1875 brick ministry shop (see Plate 90) of the central ministry at Mount Lebanon.

The Hancock shop was once on the south side of Route 20 (see Plate 1), then was moved across the road in 1829 to help make way for the new dwelling house. The shop contained retiring rooms for members of the ministry on the second floor (see Plate 91). The ministry workshops were on both floors.

The ministry elders and eldresses ate alone, washed in their own washhouse (see Plate 92), and didn't associate with common believers after 1792, just with the family elders and eldresses to whom they gave counsel on temporal and spiritual matters. Further, they oversaw the activities of the deacons and trustees, whom they could appoint or dismiss.

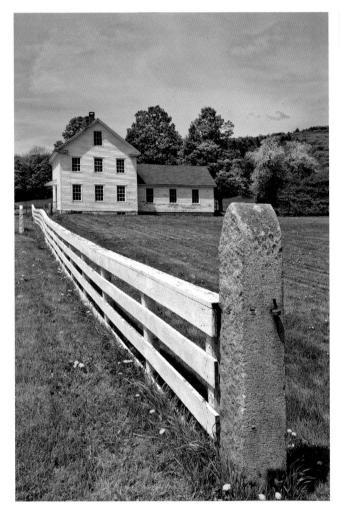

| Plate 89 |

| Plate 90 |

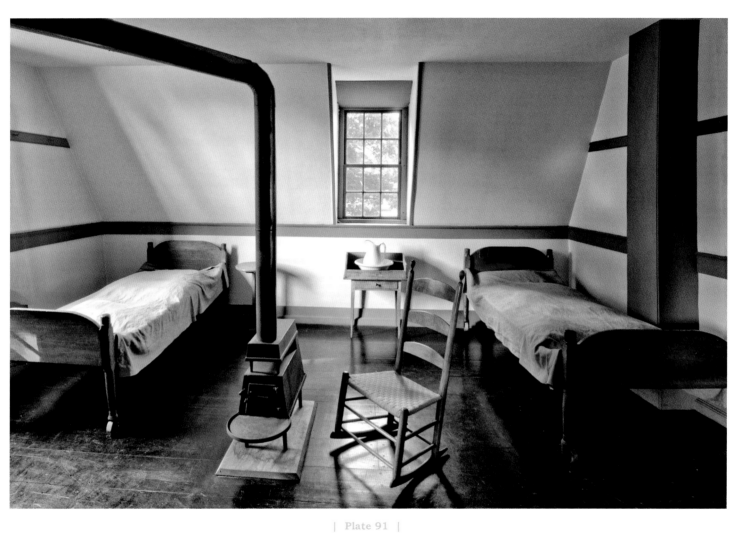

| Plate 91 |

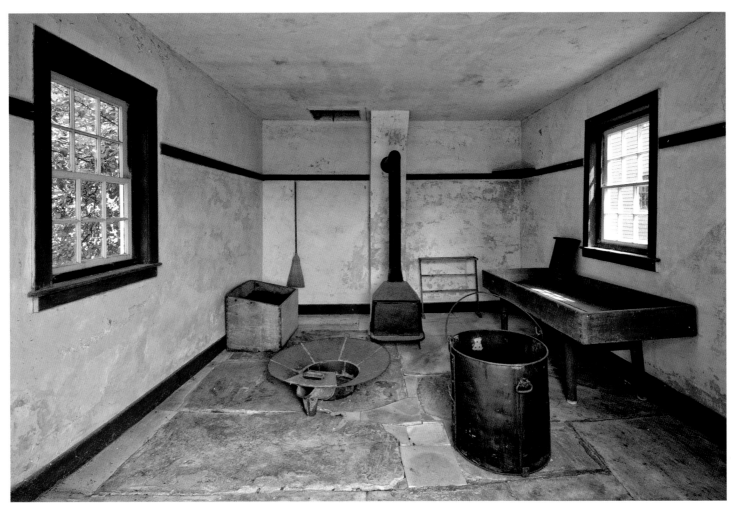

| Plate 92 |
Ministry wash-house at Hancock Shaker Village

| Plate 93 |

The Ministry's office at Hancock Shaker Village

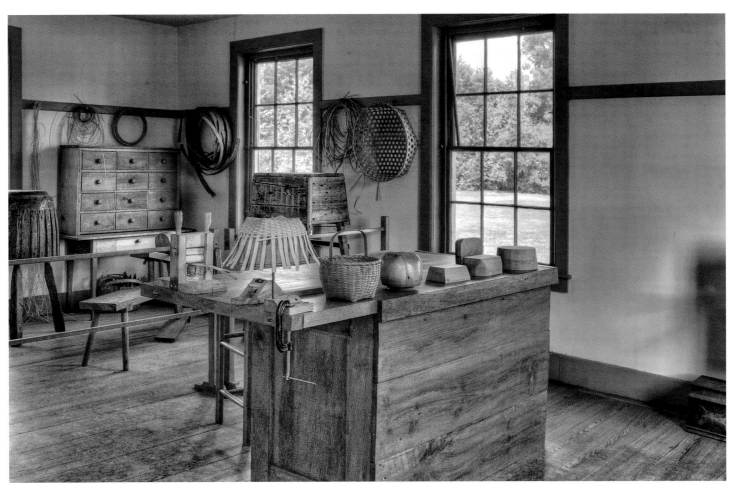

| Plate 94 |

Ministry's workshop at Hancock Shaker Village

SCHOOL AND SCHOOLING

Teaching of youngsters, ages six to sixteen for boys and six to fourteen for girls, started in 1791 at Hancock and in 1790 or earlier at Mount Lebanon. The schoolhouse at Hancock was probably constructed sometime around 1820, since a school district was formally established at Hancock on March 2, 1820. Bringing children into the village and caring for them was one way the Shakers anticipated gaining new converts. Since many children of the first generation of Shakers (i.e., the Goodrichs, the Tallcotts, the Darrows) had stayed, why not the orphans or children legally put into their care by parents or guardians? It was done at considerable expense: several sets of clothing and shoes had to be made for spring/summer and fall/winter just about every year, and there was the cost of housing, feeding, educating, and providing for caretakers to watch over them. The children helped with chores indoors and outdoors when not in school. The boys went to school from November to March, and the girls during the summer months.

The original schoolhouse at Hancock was sold in 1934 for tax relief purposes, and was turned into a private dwelling just down the road from its original site. It is the only building at Hancock that has been totally reconstructed. The school (see Plate 95) was completely reconstructed in 1978 by builder R. H. Davis of Antrim, New Hampshire, with the supervision of architect Terry Hallock.

In a general sense, schooling was directed at making good Shakers: developing good habits, learning to care for others, and developing useful talents. Of course, learning to read, write, spell, and do arithmetic were the basics. A force for new initiatives in education at Mount Lebanon very likely came from the successful program at the Western Shaker community of Union Village, Ohio, which, by 1811, had 110 students learning all the basics plus speaking and manners.

In 1823 Seth Wells, a Shaker teacher from the Watervliet community outside Albany, New York, was appointed to upgrade the Shaker schools. He traveled to the eastern communities and instructed them in new teaching methods and in new subject areas. In 1832 he became superintendent of all Shaker schools. He then instituted not just an emphasis on character training and the practical arts, but opened instruction, albeit somewhat limited, in new subjects such as algebra, astronomy, and agricultural chemistry.

Nothing was elaborate about Shaker schools. At Hancock (see Plates 96–99), students sat on benches, had a chalk board to write on, and a stove to keep the small, one-room schoolhouse warm in the winter months of the 1800s. The schoolhouse was a typical nineteenth-century one, and serviced Hancock as well as several surrounding, non-Shaker communities. The Hancock school received high praise in 1839 for its schooling. The praise would have been even higher had they had a six-month school session instead of a four-month session.

With a declining number of believers and fewer children, the Hancock Shakers shifted the classroom indoors to Room 19 in the dwelling house in the 1900s (see Plate 99).

Plate 100 takes us to 1879 at the Mount Lebanon school. There are several caretakers/teachers in the room with the students. The latter are using books and are sitting in chairs, not on benches. Shakers were always worried about the intrusion of the outside world into Shaker life through education, and they were correct that outside forces would have an impact. As education became much more important to the Shakers, more money would come from both the school district and the Shakers, bringing about further changes to the school's infrastructure, curriculum, and the introduction of new teaching methods.

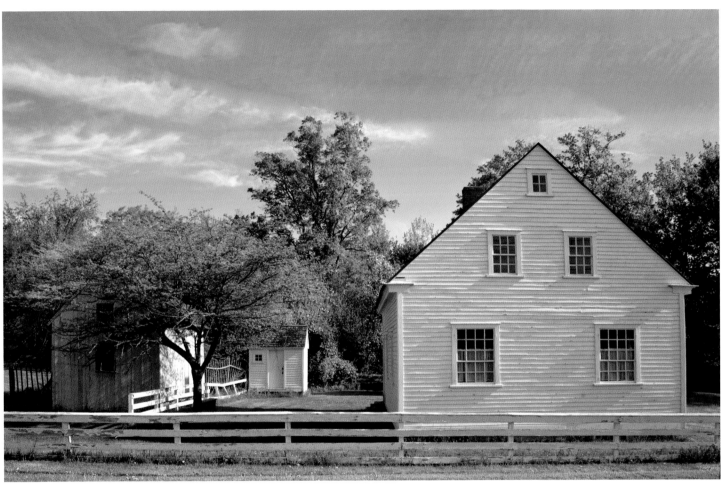

| Plate 95 |
Shaker schoolhouse at Hancock Shaker Village

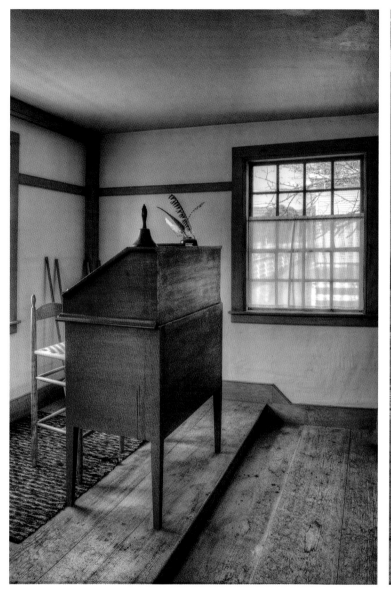

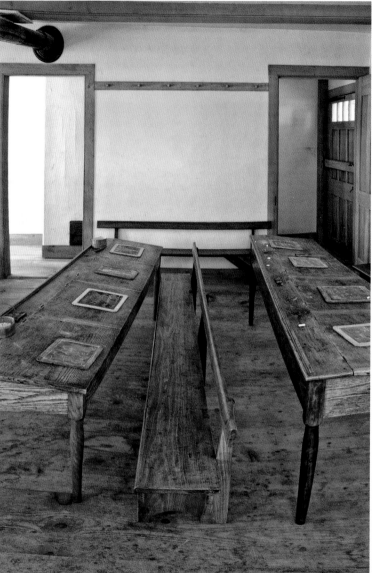

| Plate 96 | | Plate 97 |

| Plate 98 |

89

| Plate 99 |

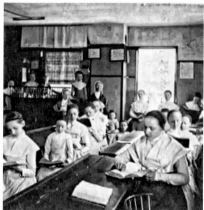

| Plate 100 |

The Round Stone Barn at Hancock

The stone barn (see Plate 101) was aptly described by J. G. Holland in his *History of Western Massachusetts* (1865):

> It is 270 feet in circumference. The walls, laid in lime, are 21 feet high and between two and a half and three and a half feet thick, the mast and rafters, 53 feet long, are united at the top [see Plate 103]. The stables, on the lower floor, are 8 feet high and 12 feet long. The mangers face inward, with convenient places for throwing hay and feed from above. The covering of the stables which could house 52 horned cattle, is the main floor of the barn, onto which, from an offset on the south side, is a doorway [see Plate 104] for teams which can make the circuit of the floor and drive out the same way. The hay was thrown-down into the large area in the center. Originally the barn had a conical roof. When a fire on December 1, 1864, destroyed the superstructure, it was rebuilt with a circular loft with a louvered turret for light and air, like a small hat box on a larger one.[13]

You'll note in Plate 105 the cylindrical wooden structure running top to bottom in the stone barn. Also note how wide the doorways are in the barn (see Plate 106). Cows could enter or leave through them. When the stone barn is filled with hay, 100 tons or more, the hay at the bottom of the pile is under pressure, which, in turn, causes a rise in temperature of the compressed hay, as well as decomposition. To avoid overheating and possible spontaneous combustion of the hay, the central wooden tube acted as a vent. Wind-driven air coming through the windows and large doorways was sucked up and out of the barn via this central wooden vent and through the louvered windows in the turret, thereby cooling the hay as it pulled the hot air with it.

The fire of 1864 was in December, when 100 tons of hay was in the original barn, but there were neither louvered windows nor a turret. The cost of the fire was estimated to be between $8,000 and $10,000. In today's dollars, the latter figure would be $400,000 to $500,000. Arson was suspected.

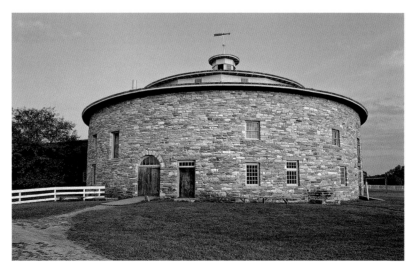

| Plate 101 |

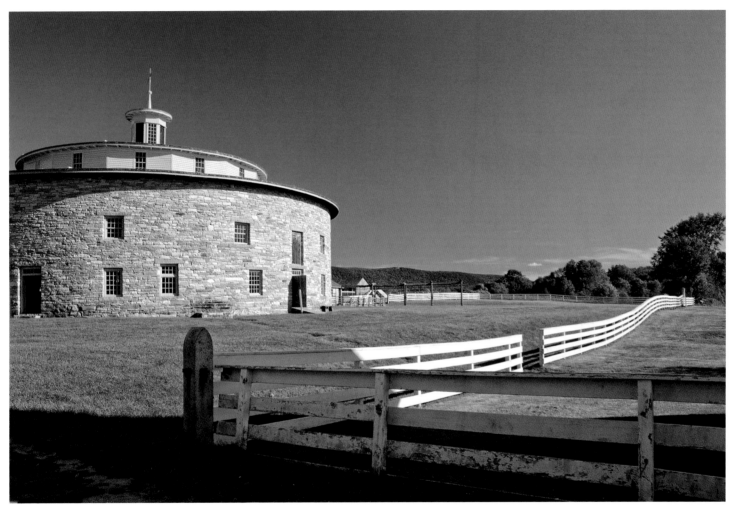

| Plate 102 |

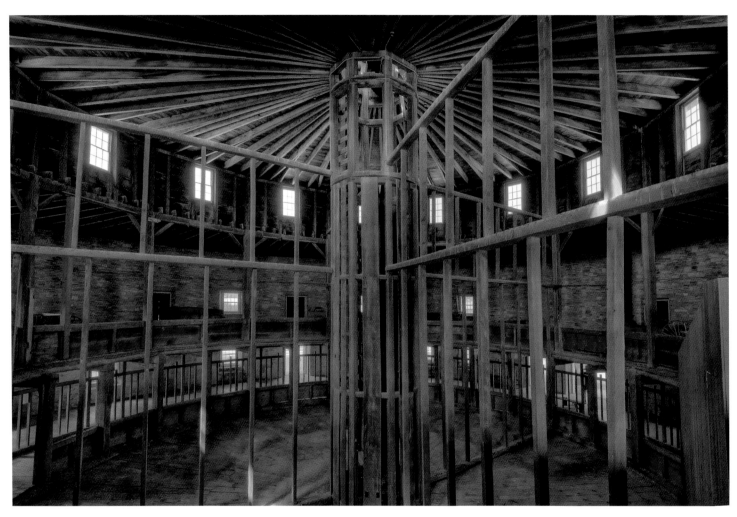

| Plate 103 |
Central venting column within the hay mow

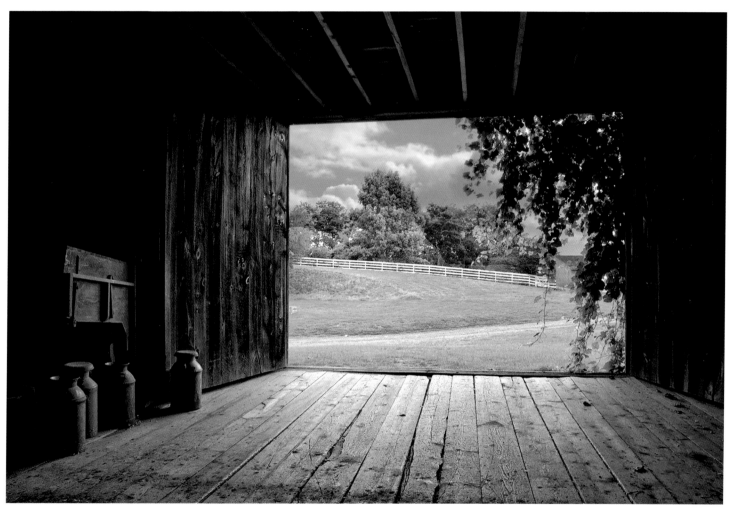

| Plate 104 |
Hay wagon entrance on the second level of the
Round Stone Barn

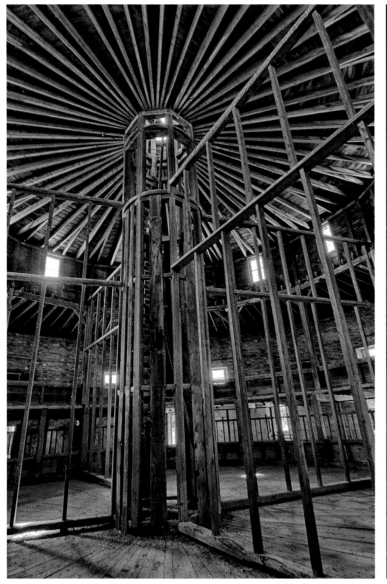

| Plate 105 |

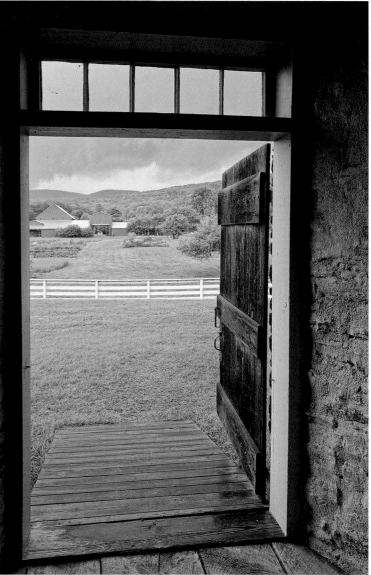

| Plate 106 |
Side door of the Round Stone Barn at Hancock Village.

The Great Stone Barn at Mount Lebanon

Barns served all kinds of simultaneous purposes: storage of hay, storage of farm equipment, and housing of animals. The Great Stone Barn of the North Family at Mount Lebanon (Plate 107) was something to behold. It was built in 1859 as the family started to enlarge its dairy business. It was nearly 200 feet long, 50 feet wide, and 55 feet high (equivalent to a five-story building). Its walls of stone encompassed around 50,000 square feet of space when including the three small wooden wings. It was used to house cows, bulls, hay, grain, ensilage, manure, and farm equipment. In its day it was among the largest stone barns in the country.

As one can see on the left of Plate 108, there is an entrance whereby hay wagons entered the third floor and dumped their loads into the hay mows below, similar to the arrangement in the Round Stone Barn at Hancock. The hay storage capacity was over 78,000 cubic feet.

On September 28, 1972, the barn burned down, leaving only the stone walls which, only now, are being repaired. Arson was thought to be cause of the fire.

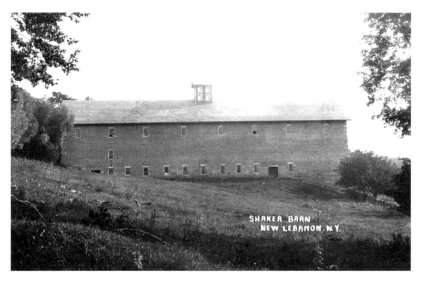

| Plate 107 |

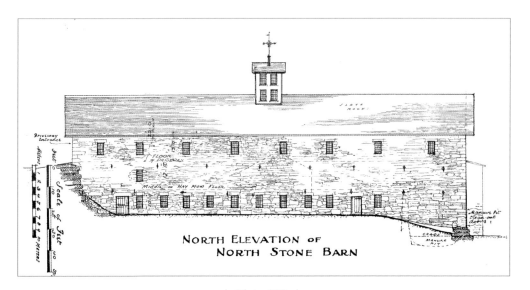

| Plate 108 |

The Horse Barn at Hancock

A pink horse barn (see Plate 109) will undoubtedly catch your eye when you are driving west on Route 20 from Pittsfield, Massachusetts. It was re-erected (disassembled and reassembled) in 1850 by a non-Shaker by the name of Mathew Criteden. Then along came Elder Louis Basting of the Church Family at Hancock, who had the barn painted pink and used it for carriage horses, his favorite being a horse named Charlie. Today, the barn houses sleds and all sorts of horse-related paraphernalia (see Plate 110).

The barn was unusual for its time with its two large bay doors, east and west, so that a hay wagon could drop off hay and continue straight through without having to back up. Its twelve-over-eight glass window panes were also an unusual feature for a barn.

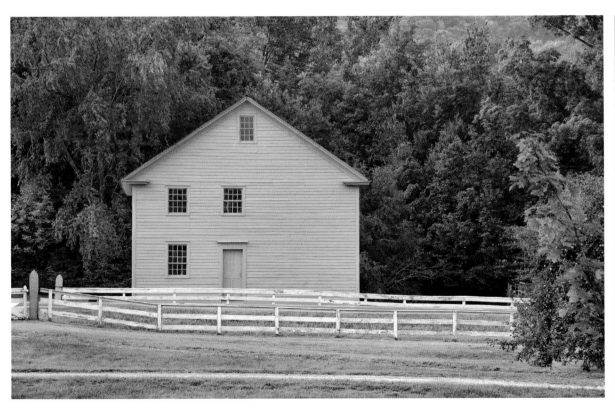

| Plate 109 |

| Plate 110 |

97

Silos at Hancock

The twin tower silos at Hancock were probably built sometime after 1880. The upright silo was first invented in 1873 by Fred Hatch of Illinois, followed by the invention of the tower silo by Franklin King a few years later.

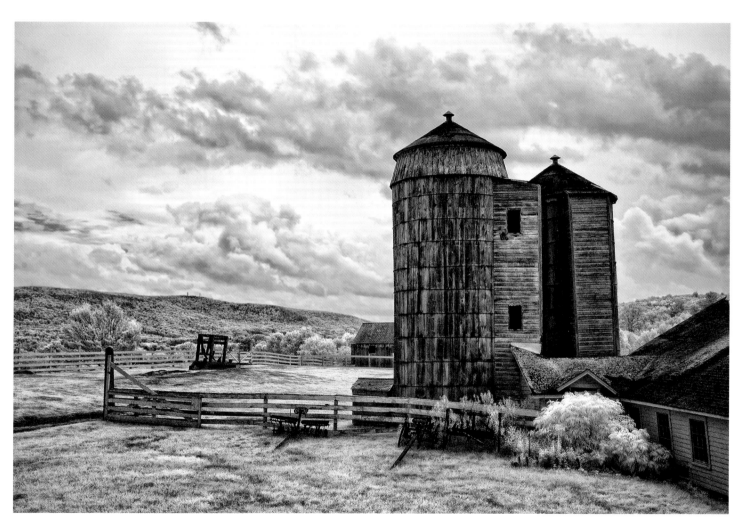

| Plate 111 |

Ever since masons were hired and boarded for the building of the stone wall of the Round Stone Barn at Hancock in 1826, hired help had been used in the village, but it became a much more frequent practice after 1860. In fact, the historian Charles Nordhoff stated that at least 350 hired hands were working throughout the eighteen Shaker communities by 1874. Neither Hancock nor Mount Lebanon were immune to the need to hire outsiders, even though it was fundamentally in opposition to Shaker principles concerning interactions with the world.

Ira Lawson, the trustee at Hancock, hired one hundred hands to harvest ninety acres of sweet corn in 1873, and the next year there were twenty-five hired laborers, some boarded and some local, at Hancock to do farming chores and to work on building projects. Those who boarded stayed in the 1793 second dwelling house of the Church Family, which was turned into a Hired Men's Shop. On March 4, 1907, the shop caught fire and burned to the ground. Around 1820, elder/trustee Joseph Holden replaced the destroyed structure with the old seed house. It was moved from the north side of Route 20 to its present position, right next door to the trustee's office (see Plate 112). This building at one point housed a printing operation. At the North Family at Mount Lebanon there was also a hired men's shop called the Hireling's House, dated 1840. It too was a two-story structure.

The presence of outsiders, especially laborers, frequently led to problems of varying sorts. Hired men were expected to abide by rules set down by the elders or trustees, but in some cases they didn't. Recurrent problems with drunken behavior happened at some communities; unwarranted advances toward the sisters were another problem. In fact, it almost reached a point of open rebellion by the sisters in the case of Mount Lebanon's South Family. This took place in the second decade of the twentieth century, when sisters refused to be in presence of hired help. Elder William Anderson made little attempt to keep the hired men in line to prevent clashes with the sisters, who were up in arms about the behavior of the hirelings and the non-action taken by Elder Anderson. It was only partially settled when Anderson turned control of the South Family's farm over to the sisters. The confrontation between the sisters and Elder Anderson dragged on until Anderson's death in 1930.

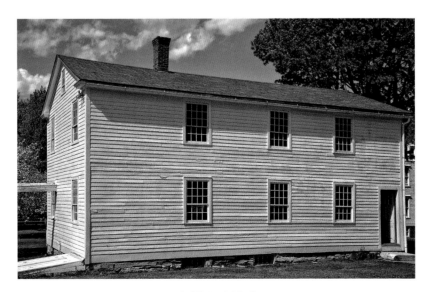

| Plate 112 |

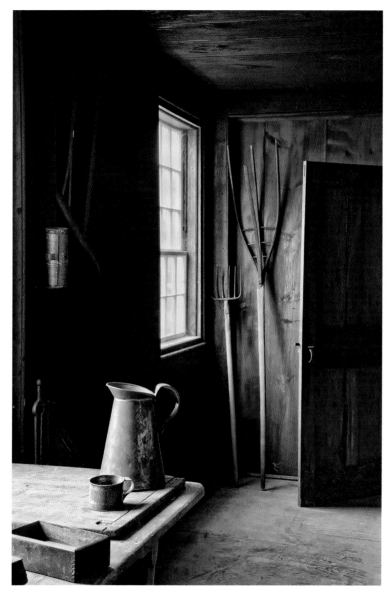

| Plate 113 |
A corner on the 1st floor of the Hired Men's Shop at
Hancock Shaker Village

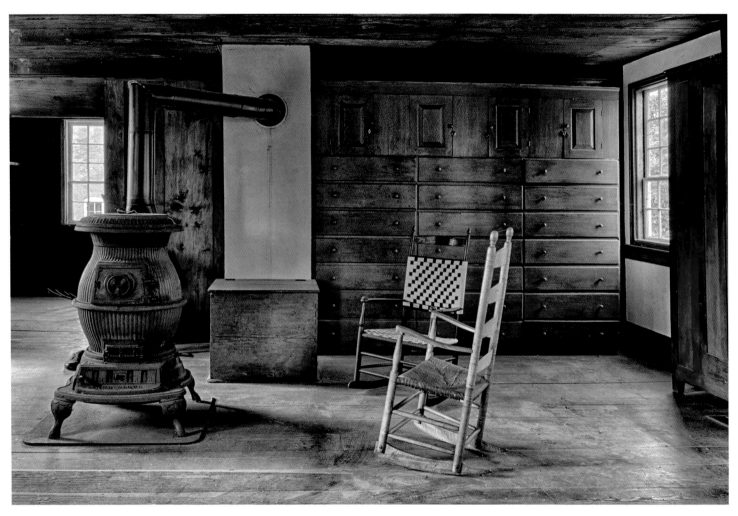

| Plate 114 |
First floor of the Hired Men's Shop at Hancock Shaker Village

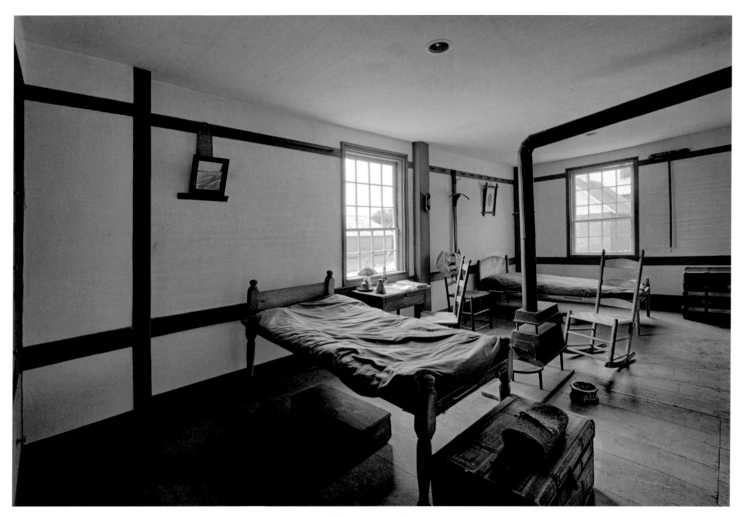

| Plate 115 |
Second floor bedroom at Hired Men's Shop at
Hancock Shaker Village

The poultry house at Hancock was rather unusual. In fact, it was quite different from the usual two-story, gray wooden chicken barns that dotted the New England landscape. The fact that it was brick with a slate roof (see Plate 116) indicated it was of importance to the Shakers, who kept poultry for meat, eggs, and feathers. Since it faces south with a large number of windows, the chickens must have liked it in the winter and may have given forth lots of eggs. Built in 1878, it was one of the last buildings constructed at Hancock. Today it's used as a gallery.

Preservation of meat and vegetables was a daily task in any agricultural community in the 1900s; therefore icehouses were common among Shaker families. The North Family at Mount Lebanon had a fairly large one in close proximity to a reservoir from which to procure ice in the winter. The Church Family's icehouse burned down in the great 1875 fire.

At Hancock, the Second Family had an icehouse in 1844; the Church Family built one in 1866 just east of the tannery then another in the same location in 1894. The latter icehouse came with improvements. It was 22 by 34 feet with walls 18 feet high. It could store 200 tons of ice, which, when insulated by hay and sawdust, would last for months on end. The house was built into a hill (see Plate 117), which added further insulation and cooling during the summer month since the ground temperature, four or five feet down, hovers around 55 °F, even in the summer. Ice was cut in blocks from a nearby reservoir and Richmond Pond. It was then dragged and placed in the upper part of the icehouse where natural, cold air convection drove the cold air to the bottom food-storage rooms, thus helping to preserve the foodstuffs.

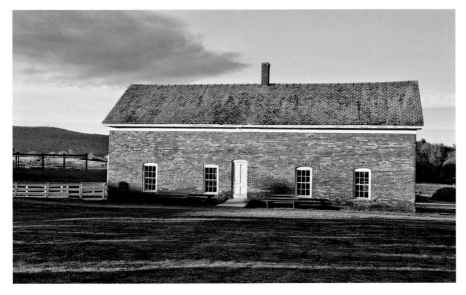

| Plate 116 |

| Plate 117 |

FIRE FIGHTING

Since our form was made up, there has occurred, in the centre, or Church Family, at Mount Lebanon—on February 6—the greatest and most destructive fire ever experienced by Believers. Eight buildings—dwelling house, Sisters' shop and wood-house combined, ice-house, storehouse, barn, cart-house, cider mill, gas-house and shed, entirely consumed. Two other buildings, with their contents, damaged. Total loss estimated at $100,000.

Pittsfield, eight miles distant, was telegraphed and sent fire brigade, with engine and 1,000 feet hose, which came through in fifty-five minutes, and did good service in extinguishing the fire.

The neighbors turned out in mass. The Tildens came in force, bringing a good supply of fire extinguishers, with parties to use them.

To all, we tender our grateful acknowledgements, for aid and sympathy.

Young George Tilden was efficient in saving the infirmary. To H. A. Tilden, Marvin Sacket and H. Whiting, we are indebted for valuable suggestions in saving other buildings, especially the Meeting House.

Incidents and Accidents

Elders Daniel Boler and Daniel Crossman both injured. Andrew Barett, collar bone broken. Eldress Harriet Goodwin was barely saved by being taken, by ladder, from an upper window. No insurance—internal or external—the loss presses heavy upon the whole Order. Prompt payment of debts due to Shakers, would much relieve.[14]

—The Shaker Manifesto vol. 5:3 (Mar. 1875)

Fires occurred over the years at Hancock and Mount Lebanon. Once a fire got underway in a building, it was certain to engulf the structure completely. A partial list of the fires at Hancock includes these:

1825, First Family cow barn
1905, Brethren's Shop of Second Family
1864, Round Stone Barn
1907, Hired Men's Shop at Church Family
1865, Woolen mill at the North Family
1911, Calf barn
1868, Sisters' Shop of Church Family, and village infirmary
1915, Grist Mill

At Mount Lebanon, fires in February 1875 were horrific, as expressed in the note posted in the *Manifesto* of March 1875. In the same month and year as the great fire, February 1875, a second fire destroyed the herb house at an estimated loss of $50,000, about $2.5 million in today's dollars.

Shakers were so concerned about fires—with good justification—that there are fifteen orders in the 1845 Millennial Laws pertaining to fire prevention. The first order reads: "No one is allowed to carry fire about the dooryards, or among the buildings, unless safely secured in a lantern, fire-box, or other safe vessel."[15]

Plate 118 depicts the utter destruction that resulted when a fire started in a structure, even one of stone. This building once was the sisters' workshop at the Second Family Mount Lebanon.

Plate 119 shows a barn fire at Mount Lebanon on November 8, 1912, which led to complete destruction of the barn. Fires still did enormous damage in the early 1900s. Note that no one is fighting the fire, just observing, which suggests that fire-fighting equipment here was inadequate or not available even by 1912.

In 1972 the Great Stone Barn at North Family caught fire, thought to be due to arson. Today, the Shaker Museum at Old Chatham, New York, is working to save the structure with hopes to rebuild it in the future. Wall supports (see Plate 120) keep the stone walls up, and recementing the stone joints is a work in progress to keep the walls intact.

off
104

| Plate 118 |

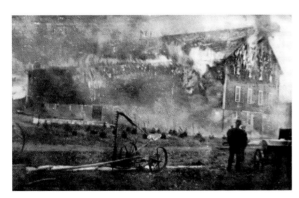

| Plate 119 |

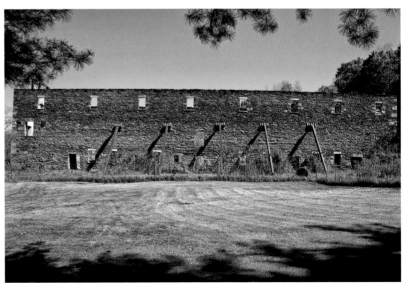

| Plate 120 |

In 1896 a description of the Hancock Shaker cemetery was published in the Pittsfield newspaper.

> There are probably 250 graves in this little yard, and they are all arranged in rows with the regularity of a chalk and plumb line, and at the head of each grave is a small plain marble slab, a little over 2 feet tall and a little more than a foot wide, and of those 250 slabs, less than a dozen are in any way ornamental, all of the other being practically identical as to size, shape and general appearance. On none of the marks of the graves of the shakers is there anything concerning the life of the one whose resting place it marks, save the name, the date of death and the age. No fine gravel walks lead up to the "city of the dead" and no winding paths pass in and out among the graves; yet all is neat; and its extreme simplicity renders it attractive.[16]

In 1943 the gravestones were removed and a single monument erected, with the intent to treat all those buried as equals (see Plates 121 and 122). The inscription of the monument reads:

<div align="center">

In Loving Memory Of Members of the Shaker Church
Who Dedicated Their Lives To God
And The Good Of Humanity Passed To Immortality
Erected by the Westfield Pittsfield and Hancock Mass.
Community in the year 1943

</div>

Prior to the decision by the central ministry to remove headstones, the cemeteries had small grave markers as shown in Plate 123; nothing ostentatious, just simple markers. In all cases the initials of the deceased were inscribed, and in other cases the name was added.

Shakers did not believe in a physical resurrection, only a spiritual one, and being buried in a simple pine coffin was in keeping with that tenet. As Genevieve De Graw of Mount Lebanon expressed at seeing her sisters pass away:

> One by one they're passing on,
> Friends we have long known,
> But we'll meet them all again
> in our spirit home.[17]

The Shaker cemeteries throughout the northeast are very similar to what one sees at Hancock (Plate 121). Perpetual maintenance of the cemetery at Hancock was provided as part of an agreement in 1959. At that time 550 acres north of Route 20 were deeded to the state of Massachusetts to be part of Pittsfield State Forest with the provision made for maintenance of the cemetery by the state. The last Shaker to be interred at the Hancock cemetery was Fannie Estabrook, an eldress. She died at age 90 in 1960 after being at Hancock for 80 years. She came as a child of 10. The last person interred at the Hancock cemetery was Clara Sperle in 2007. She was the last girl raised by the Hancock Shakers. She chose to be buried at Hancock even though she left the Shaker community in 1918.

| Plate 121 |
Cemetery at Hancock Shaker Village

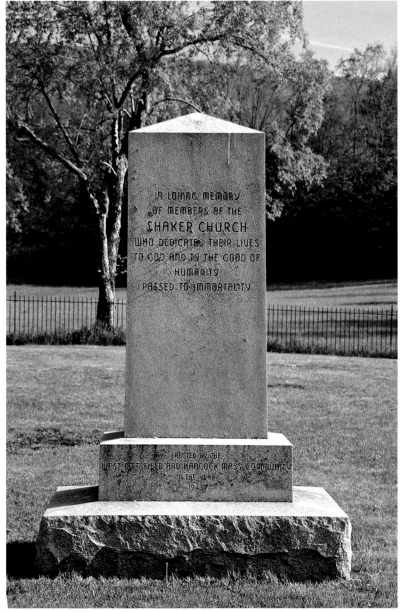

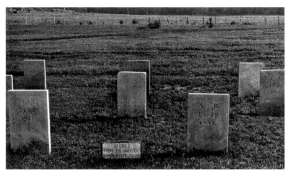

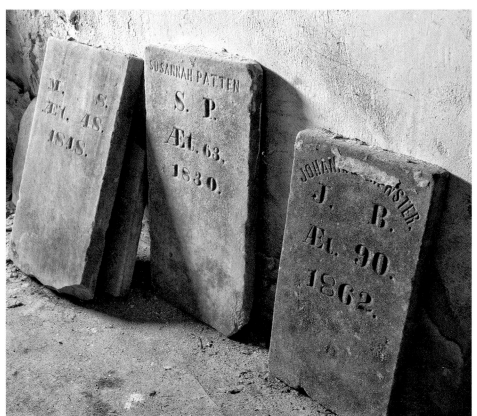

| Plate 123 |

Economic separation from the world was never a philosophy the Shakers embraced. If anything, they realized their survival depended on industry and trade with the outside world. These temporalities were the responsibilities of the trustees and deacons and deaconesses in each family within a village. In theory the trustee handled the fixed assets, represented the society in legal disputes, bought and sold property, and planned industry, while the deacons managed departments of various industries and administered to the temporal needs of the families. However, there was overlapping of responsibilities between trustees and deacons. The Millennial Laws of 1821 and 1845 made their responsibilities clear:

> It is the duty of the deacons and deaconesses, or Trustees to see to the domestic concerns of the family in which they reside, and to perform all business transactions, either with the world, or with believers in other families or societies. All trade and traffic, buying and selling, changing and swapping, must be done by them or by their immediate knowledge and consent.[18]

Outside visitors doing business with the society always came to the Trustee's Office. The offices also were guest houses for overnight visitors at Hancock and Mount Lebanon, as well as at other villages.

The office's prime purpose was to act as a supply depot for goods coming in from the world and goods going out to the world. The stores in the villages were not necessarily part of the Trustee's Offices. This was the case at the Church Family at Hancock. Plate 124 shows the sisters' store directly west of the dwelling house and bordering Route 20. Plate 125 shows the interior of the Hancock shop, taken in or after 1913. At Mount Lebanon, the North, Church, and South Families had visitor stores at their Trustee's Offices following the pattern at Hancock.

After a series of renovations and changes, the Hancock Trustee's Office (Plate 126) was finalized in 1895. It started out as a small building, 28 by 38 feet, around 1790, then in 1813 the original frame was raised two and half stories—the first makeover. Then, starting in May 1852, the frame was raised again to extend the building to the south, thereby doubling its size, while reorienting its front to face west, and putting in a kitchen and a visitor dining room—the second makeover. It took seven months to complete this renovation, which was followed by minor additions in 1876.

Next, Ira Lawson, the Trustee, flush with cash from potato and apple sales and royalties from the mining operation, decided to renovate the Trustee's Office. It was done over in a sedate Victorian style as seen in Plate 126. Better accommodations to promote community sales by the office deaconesses may have prompted Lawson to do the renovation. He was too practical a person to do things for frivolous reasons. Compare Plate 126 to Plate 127, which shows the Trustee's Office and store at the Church Family at Mount Lebanon. As the Shakers moved into the twentieth century, electricity came in 1913 to the Hancock office, followed by steam heat and indoor plumbing around 1920.

The tastes and styles of the outside world started to encroach upon the Shakers' way of life starting toward the end of nineteenth century. And by the first quarter of the twentieth century, many were fully entrenched. The Shakers were still trying to enlist converts and to look progressive; hence adoption of a Victorian-style Trustee Office, a conventional living room (Plate 128) with its hanging pictures and wallpaper, and in the store, linoleum on the floor and wallpapered walls (see Plates 129 and 130).

Plate 124 depicts the sisters' store and workshop, which was torn down in 1958. Behind the store to the left is the brick dwelling house.

There is no date associated with Plate 125 but, due to presence of an electric light, it had to have been taken in 1913 or thereafter at Hancock. Baskets, towels, clothing of all sorts, braided rugs, and an assortment of knickknacks were the main items for sale.

| Plate 124 |

| Plate 125 |

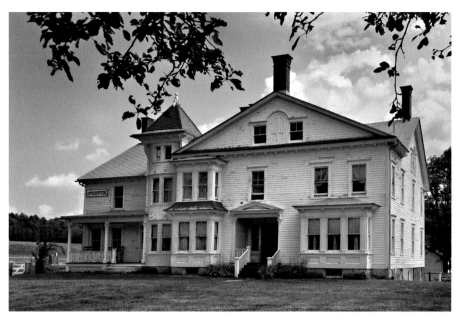

In the 1950s and until 1960 the Trustee's Office was home to Frances Hall, the last trustee/ eldress at Hancock, who died in October 1957, and to eldress Fannie Estabrook who died in September 1960.

The three-story Trustee's Office and Store of the Church Family at Mount Lebanon is shown in Plate 127 as it stood in 1938. Note how simple and plain the building is. It appears it could accommodate many overnight visitors.

| Plate 126 |
Hancock Trustee's Office

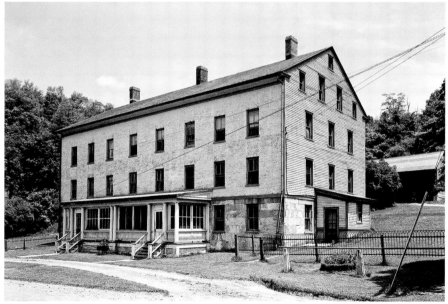

| Plate 127 |

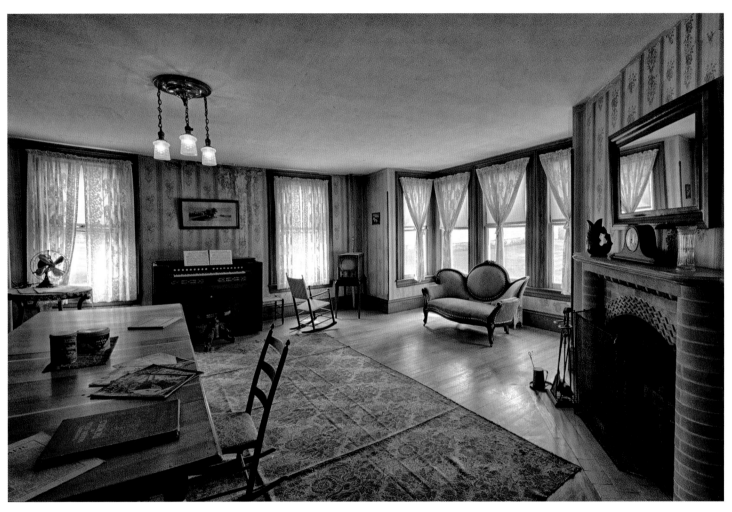

Parlor at Trustee's Office at Hancock

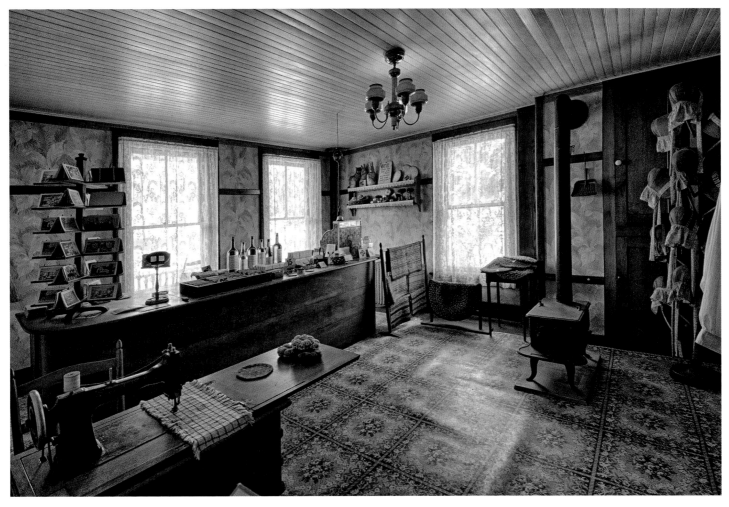

| Plate 129 |
Store at Trustee's Office at Hancock Shaker Village

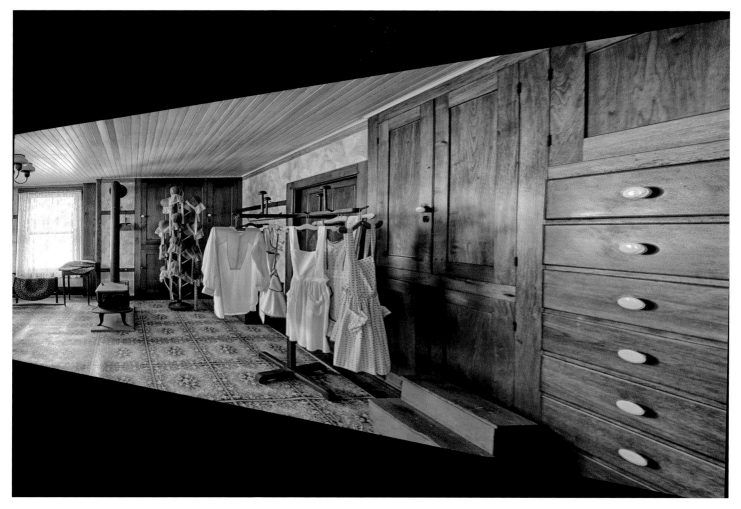

| Plate 130 |

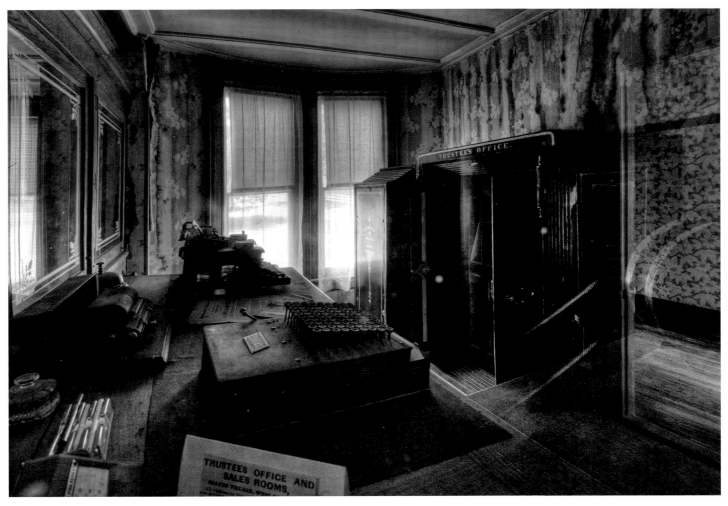

| Plate 131 |
Enclosed record and cashier's office at Hancock

Before all else in the way of buildings, the meeting house was the first structure to be built in a Shaker village. It was, after all, a manifestation of their faith. Religious and spiritual activities of all kinds—revival meetings with their revelations through spiritual manifestations, reciting of hymns, and dancing and shaking to music—took place in the meeting house. It was a place to gather all the village families to profess their beliefs and make testimonies to their faith.

In some cases, non-Shakers were allowed to attend Shaker gatherings at the meeting house, with the hope of getting converts. Visitors came on weekends to observe Shakers practice their religion, which was made even easier after 1841 when a train depot was opened in Pittsfield, Massachusetts, by the Boston and Albany Railroad connecting both Boston and Albany to Pittsfield.

The meeting house at Hancock was started in August 1786 by Moses Johnson of Enfield, New Hampshire. An identical meeting house had been raised in October 1785 by Johnson at Mount Lebanon on land donated by George Darrow. Both structures had gambrel roofs, woodwork painted a glossy Prussian blue, white walls, and outside steps carved out of block marble.

The current meeting house at Hancock Shaker Village (Plate 132) came from Shirley, Massachusetts, and was re-erected in 1962–1963. The main room was on the first floor and had movable benches and no internal, vertical supports, thus plenty of room to move around unhindered (see Plate 133). Shakers were always improving on things, so in 1871 the original meeting house had its roof raised, more windows put in, and the front renovated. Plate 134 shows the renovated meeting house with its gable roof.

From 1874 to 1925 the membership declined by an estimated 91 percent and the meeting house eventually was not needed. It was used instead for storage. Then, in 1938, the meeting house was dismantled to lessen the tax burden and to eliminate another potential fire hazard.

With real growth in the number of believers in the second decade of the nineteenth century at Mount Lebanon, it was decided by the central ministry that a second meeting house was needed.

A barrel-roofed structure (Plate 135) was built in 1824. It was capable of holding more than 500 members. The total cost at that time was estimated by Brother Alonzo Hollister to be more than $16,000 even with help in building coming from brothers at Hancock; Enfield, New Hampshire; Watervliet, New York; and Shirley, Massachusetts. To help with the costs, Shakers at Hancock, Canterbury, and those of the two Enfield communities (in New Hampshire and in Connecticut) contributed upwards of $1,100 toward the cost of the meeting house.

The structure itself was 63 feet wide and 78 feet long, and required no internal supports (see Plate 136). Two chimneys, on the north and south walls, were constructed to handle four large cast-iron stoves which were used to heat the cavernous meeting room, about 216,000 cubic feet in volume. Members of the ministry, elders and eldresses, were housed on the second and third floors, and their workshops were on the south side above the main entrance to the meeting house.

Entrance to the front section of the meeting house was through three doors (see Plate 137). The door on the left was for sisters, the center door was for the ministry, and that on the right was for the brothers. Non-Shakers visiting the religious activities came in through two side doors (Plate 138), the one on the left for men, and that on the right for women. Outside visitors sat on the wooden benches abutting the wall (Plate 139).

When the Darrow School purchased the Church and Second Family holdings in 1947, the large second meeting house at Mount Lebanon was part of that purchase. It was converted into the Heyniger Memorial Library for the school's students and faculty. The building is well maintained and the internal structure was reasonably preserved, except now instead of movable seats there are bookcases and desks.

With the publication of the *Millennial Praises* in 1813, a book of hymns, singing hymns as a form of devotion was considered acceptable. Singing and dancing at family meetings held during the week in the dwelling house could be quite chaotic, and sometimes brothers and sisters would exhibit bizarre (to those not inclined to believe in spirits) behavior. The singing and dancing on the Sabbath, however, followed prescribed rules and decorum that were instituted around 1805.

Professor Benjamin Silliman wrote in 1832:

The worship commenced by the men arranging themselves in line at one end of the room, and the women on the other, and after a few words were addressed to them by the Elder, they all kneeled down in opposite lines, facing each other, and after a period of profound silence, they commenced singing hymns from a book, the words of which were unintelligible to the auditors. At this they rose and marched backwards and forwards, facing each other, to a tune which they all sung; then they faced the wall, with the backs to the audience, and marched in the same manner, backwards and forwards toward the wall.

When this exercise ended they formed two circles, a smaller and a larger one, and marched to the tunes sung by the inner circle, which composed the principal singers; their hands also keeping time, either by the alternate motion of swinging backwards and forwards, or by clapping them together as they became animated by the tunes which were sung. This exercise continued about half an hour, when they retired to their seats.[20]

Plate 140 is a drawing of the singing and dancing on the Sabbath. With all this motion going on accompanied by the clapping and singing of songs they never heard before, the audience might very well feel they had been transported to another sphere of existence. Sisters clad in their Sabbath white caps and shawls and brothers in their Sunday best, all moving and gesturing to the music, must have made an enduring impression on the spectators.

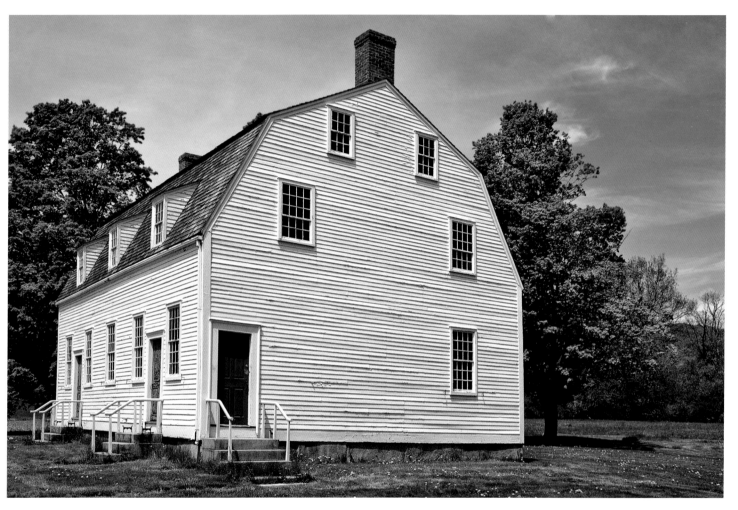

| Plate 132 |

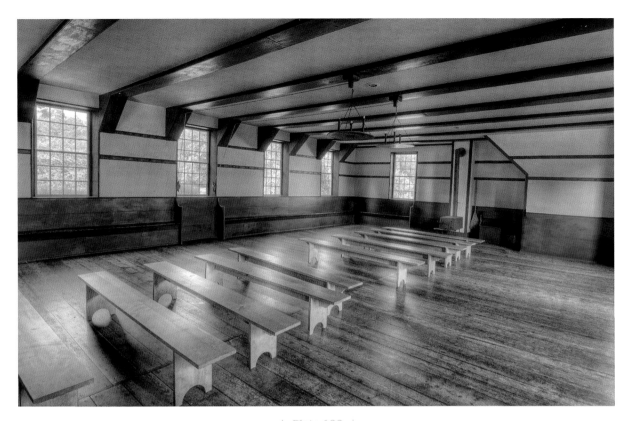

| Plate 133 |

| Plate 134 |

The interior of the meeting house at Hancock is shown in Plate 133. There were eleven such meeting houses built throughout New England and New York Shaker communities by Moses Johnson. Each house was built to the same design.

Plate 134 shows the 1871-renovated meeting house at Hancock, dating back to 1792. It was dismantled in 1938. The date of the picture is unknown but likely was taken in the 1930s.

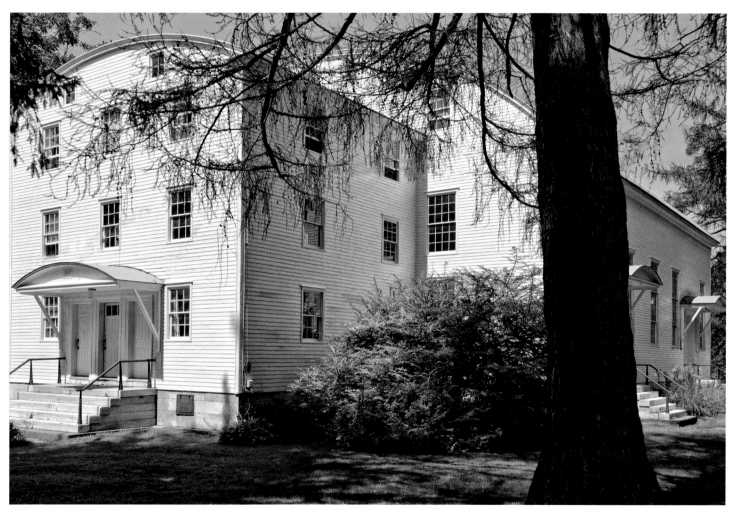

| Plate 135 |
Second Meeting House at Mount Lebanon

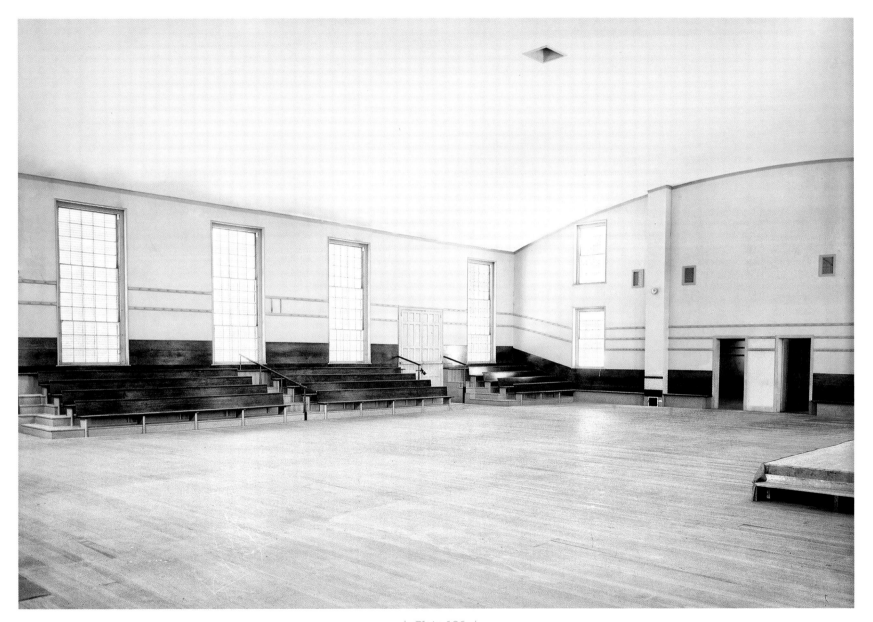

| Plate 136 |

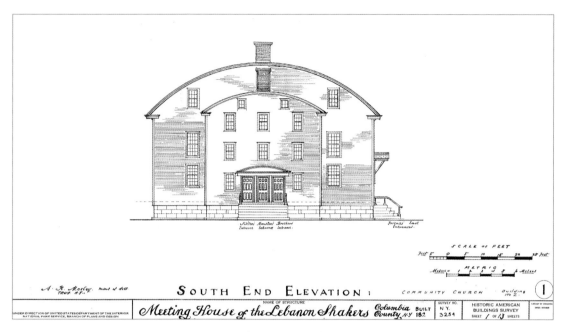

SOUTH END ELEVATION: COMMUNITY CHURCH Building No. 2.

A. K. Mosley, meas. & delt
Troy N.Y.

SCALE OF FEET

NAME OF STRUCTURE

UNDER DIRECTION OF UNITED STATES DEPARTMENT OF THE INTERIOR
NATIONAL PARK SERVICE, BRANCH OF PLANS AND DESIGN

Meeting House of the Lebanon Shakers | Columbia County N.Y. | BUILT 182 | SURVEY NO. N.Y. 3254 | HISTORIC AMERICAN BUILDINGS SURVEY | SHEET 1 of 13 SHEETS | ①

| Plate 137 |

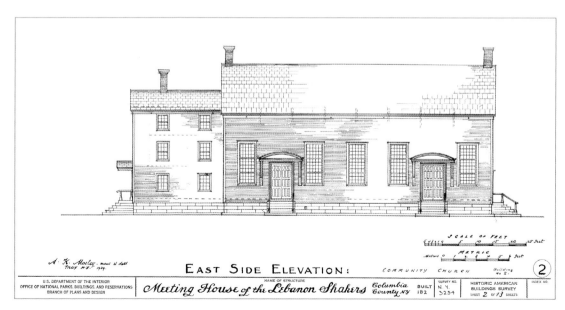

EAST SIDE ELEVATION: COMMUNITY CHURCH Building No. 2.

A. K. Mosley, meas. & delt
Troy N.Y. 1939

SCALE OF FEET

METRIC

U.S. DEPARTMENT OF THE INTERIOR
OFFICE OF NATIONAL PARKS, BUILDINGS, AND RESERVATIONS
BRANCH OF PLANS AND DESIGN

NAME OF STRUCTURE

Meeting House of the Lebanon Shakers | Columbia County N.Y. | BUILT 182 | SURVEY NO. N.Y. 3254 | HISTORIC AMERICAN BUILDINGS SURVEY | SHEET 2 of 13 SHEETS | ②

| Plate 138 |

122

| Plate 139 |

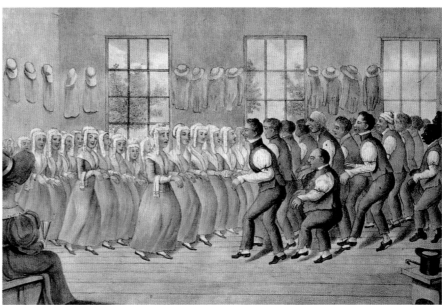

| Plate 140 |

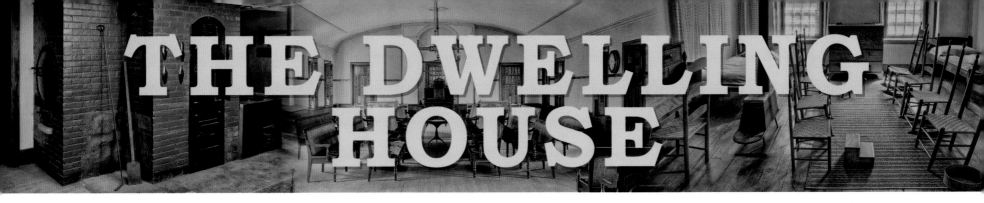

THE DWELLING HOUSE

THERE NEVER WAS WHAT ONE COULD CALL A FORMAL PLAN for a Shaker village. However, villages reflected regularity, harmony, and order when it came to where families resided and the placement of their buildings. Villages were always near main roads for trading purposes and access to people of the world. The meeting house, the religious center with its ministry and village gathering place, was one of two principal buildings, with the other being the Trustee's Office, where interaction with the world took place. In a way, these buildings were opposite in a sectarian sense. Yet, the real life of the family was involved with neither.

The primary physical and social life of the believers was focused on his or her activities at the dwelling house.

Shaker dwelling houses differed in size, style, shape, and building materials from community to community; none were the same. The six-story great stone house at Enfield, New Hampshire, was the largest dwelling house ever built (see Plate 141). One could easily see Lake Mascoma and the surrounding countryside from its bell tower. The building was designed by Ammi Young, who had designed a residence hall at Dartmouth College in 1828. Then there was the four-story brick dwelling house of the Church Family at Mount Lebanon built in 1875, which is now used as a dorm at the Darrow School. It too was a massive structure (see Plate 142). It was the second dwelling house built by the Church Family. Plate 143 shows the three-story, wooden dwelling at Canterbury, New Hampshire, first built in 1793. It was progressively altered over time; its present form was completed in 1837. The brick dwelling house at Hancock, built in 1830–31 (see Plate 144), is our focus of interest.

In 1829, William Deming, first elder of the Church Family at Hancock, decided to build a new dwelling house. The Church Family had grown and needed to place its two families, then living in separate dwellings, under one roof. Buildings such as the Laundry and Machine Shop and Ministry were moved, ten in all, to make way for the new dwelling house. The foundation was started on April 15, 1830. The building materials (sand, lime, stone, and lumber) came from Hancock, with the exception of flooring. Labor (joiners, carpenters, and masons) was provided by the village. In ten weeks the walls were up and the roof on. The house consumed 2,326 linear feet of white stone for the foundation, 895 linear feet of blue limestone, and 350,000 bricks. When all was said and done, there were 100 large doors, 240 cupboards, 369 drawers finished in buttonwood and stained, and 3,194 panes of glass throughout the 140 or so windows in the brick dwelling house. (The Shakers strove to have good ventilation and lighting throughout their buildings for health reasons.)

The dwelling was ready in late November 1831, just nineteen months after the first stone was laid. The estimated cost for the Hancock dwelling house was around $8,000, plus another $3,000 for iron pipes to carry water to the Laundry and Machine Shop, and another $400 for pipes taking water to the dwelling house kitchen. Ninety-four Shakers, 46 brethren and 48 sisters, moved into their new four-and-a-half-story home on November 22, 1831.

Exploration of the brick dwelling structure will take us from the all-important kitchen, through the first floor, and then on to the second floor. Fortunately, there are some images of rooms at some of the Mount Lebanon families to compare with similar rooms at Hancock.

THE KITCHEN

With upwards of 100 people to feed three times a day (6 a.m. in summer, 7 a.m. in winter, 12 p.m., and 6 p.m.) during the 1830s and '40s, the kitchen sisters, as they were called, had a lot of work to do to feed the sisters and brothers. When it came to heavy work, a brother was generally appointed to help around the kitchen.

Of course, the dwelling house needed a suitably-sized and well-equipped kitchen. The Church Family kitchen at Hancock was 50 feet long and 18 feet wide (see Plate 145). It had several ovens: the great vaulted oven, hot plates, and a heating oven with its circular door (see Plates 146 and 147).

The kitchen needed an assortment of utensils. For example, bread was a staple and a way was needed to slice it quickly. A bread cutter (see Plate 148), with its long wooden-handled knife, which swung on a pivot, enabled one to quickly slice through a loaf of bread. By Shaker law, bread must be eaten only after the second day out of the oven; hence, it could be hard to slice without such a device.

The kitchen itself took up the whole south section of the dwelling house basement. In addition, there was the need for four storage rooms, each about 306 square feet, to store pots, jars, grains, flours, dried vegetables and fruits, and freshly picked foodstuffs (see Plate 149). Marble flooring was used throughout the kitchen and storage areas to help keep the rooms cooler in the summer.

The kitchen was the province of the kitchen sisters and off-limits to others. The latter rule may have been a way to keep people from nibbling between meals. The sisters did rotate jobs between the kitchen and the dining room. Plate 150 shows the kitchen sisters at the North Family kitchen at Mount Lebanon. There is no date associated with this picture but it very likely was taken sometime between 1890 and 1922. It was taken by photographer J. E. West. One can see that sisters were preparing corn and what look like peppers. Note the presence of running water and the absence of electric lights, which makes it likely the image was definitely from before 1922. (The first reported electric light installed at the North Family was in 1921.)

THE FIRST FLOOR OF THE DWELLING HOUSE

There were two first floor entrances, the east door for brethren and the west door for the sisters. The first floor contained visitor rooms (separate ones for female and male visitors), the elders' and eldresses' rooms, the meeting room, the general dining room, and the room of the ministry. The first floor was the social hub for the Church Family.

Dining Rooms

Prior to all meals, the sisters and brethren would assemble, each in a group, in appointed rooms, and wait in silence for ten or fifteen minutes for the dining hall bell to ring. They then were led in two columns by an elder and eldress to the dining room, which, at Hancock, could seat eighty people at one time. Brethren and sisters ate separately and in silence, almost monastic in their behavior. They sat at trestle tables and used one-slatted chairs, all of which were made at Hancock (see Plate 151). Woodenware and pewter plates were used until around 1875 then switched out in favor of earthen- and white ware, as porcelain dishes were called. Tumblers were forbidden.

People were served in groups of four so all the food was nearby, which precluded the continuous reaching and passing of food from one to another. As for the ministry, as one would expect, they ate alone, right next door to the main dining room (see Plate 152). Everyone was expected to gather up any fragments of food on their plates, so as to leave nothing at the end of a meal.

After 1900, the intrusion of worldliness into Shaker life really seemed to have accelerated, and Shaker styles were supplanted by worldly ones.

Compare Plates 153, 154, and 155 of the dining rooms at Hancock and the Church and North Families at Mount Lebanon, to the circa-1840 dining room in Plate 151. The intrusion of the world into Shaker life is apparent: white paint on all the beautiful Shaker woodwork, the linoleum flooring, absence of Shaker chairs and tables, and pictures or ornaments hanging here and there in these dining rooms.

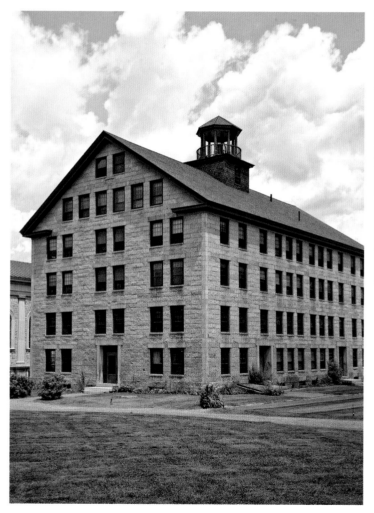

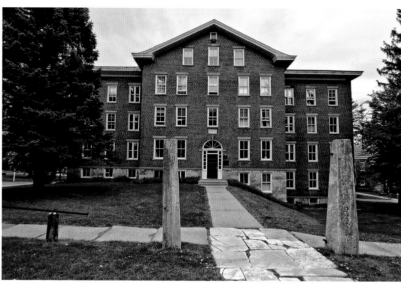

| Plate 142 |
1875 Church Family dwelling house at Mount Lebanon

| Plate 141 |
The 1837 Great Stone dwelling house at Enfield, NH

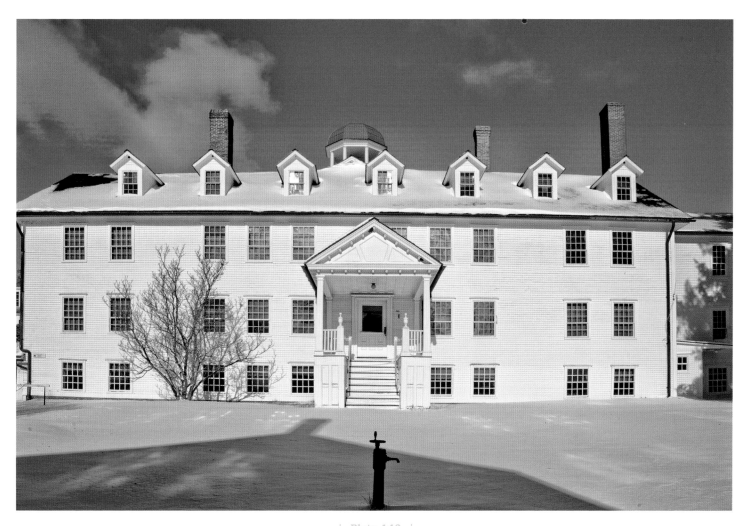

| Plate 143 |
The dwelling house at Canterbury, NH

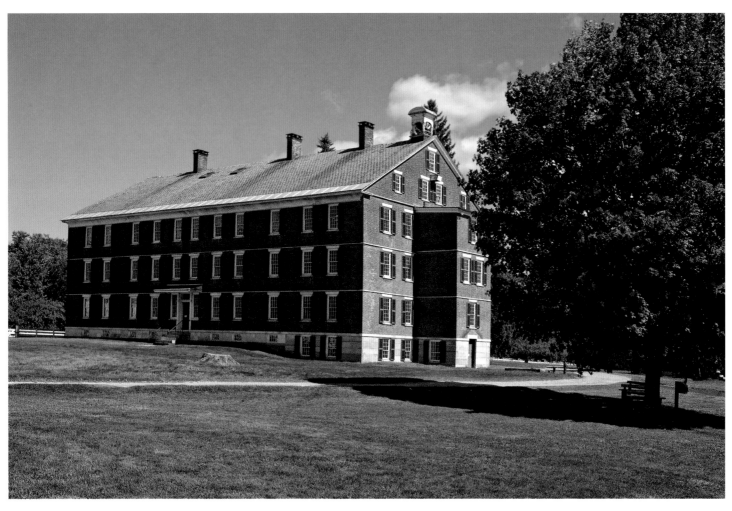

West Side of the Church Family's brick dwelling house
at the Hancock Shaker Village

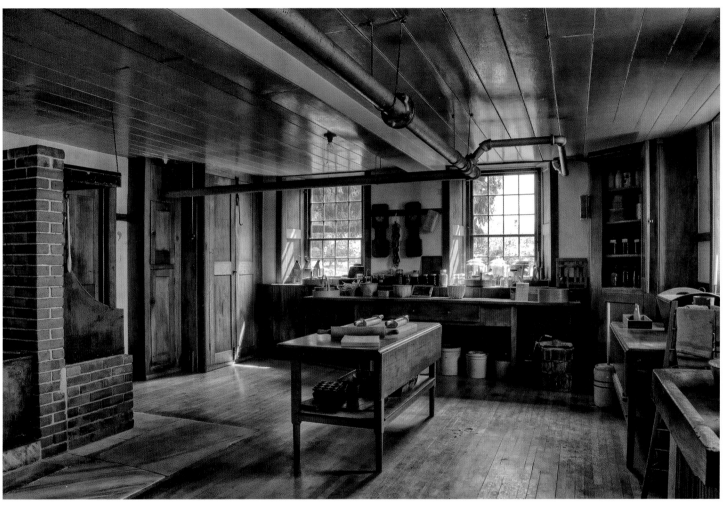

| Plate 145 |

Kitchen at the Hancock dwelling house

| Plate 146 |
Kitchen ovens at the Hancock dwelling house

| Plate 147 |

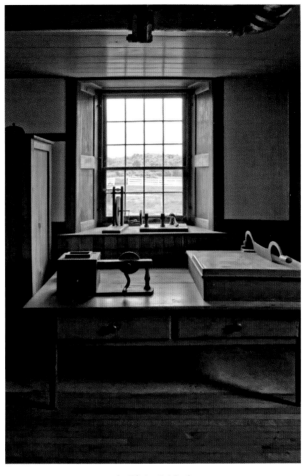

| Plate 148 |
Bread cutter on far right

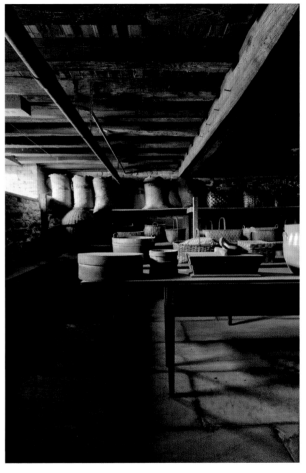

| Plate 149 |
Kitchen storage room at the Hancock dwelling house

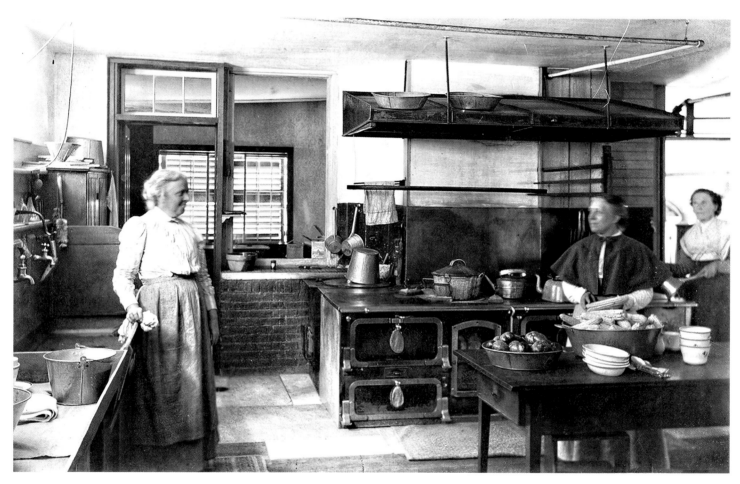

| Plate 150 |

132

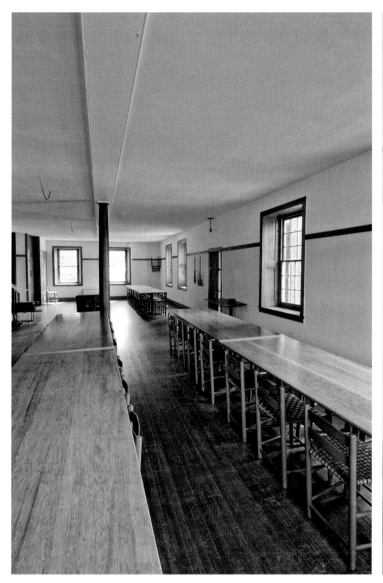

Circa 1840 dining room at Hancock

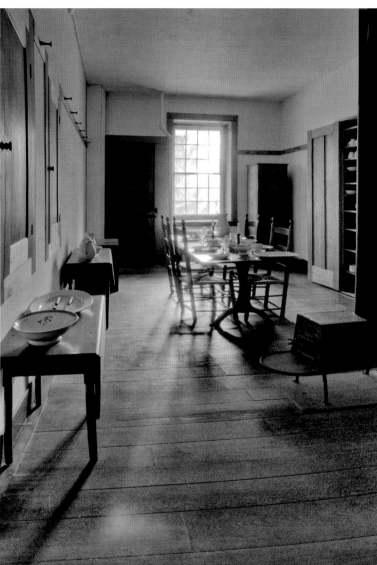

The ministry dining room at Hancock

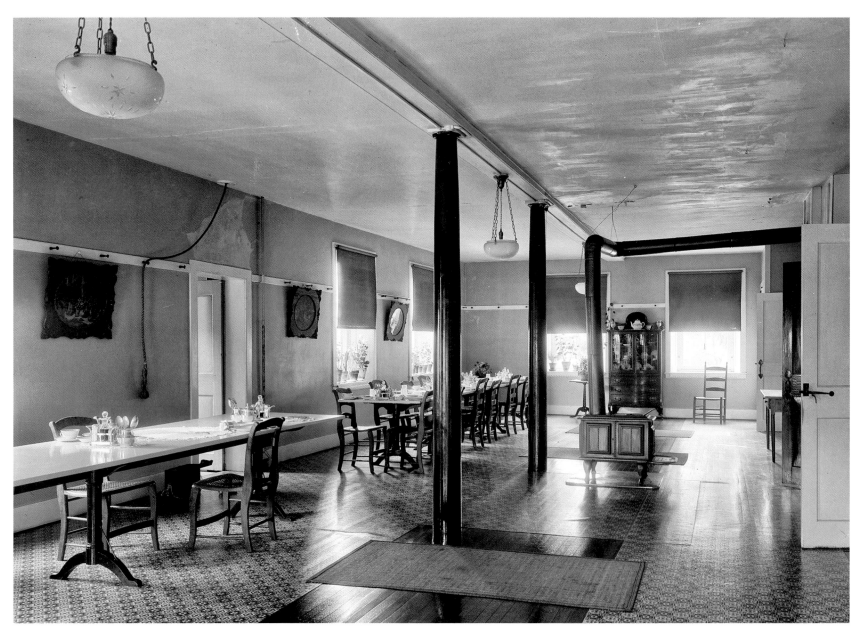

| Plate 153 |
The dining room at the Hancock dwelling house,
dated 1931

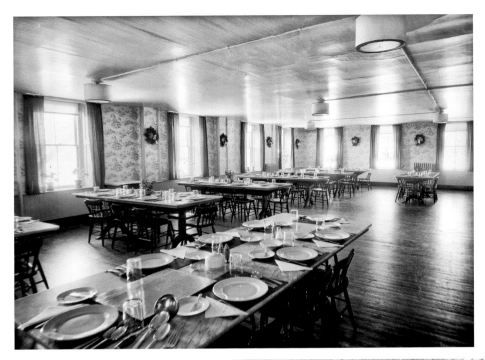

| Plate 154 |

Church Family dining room at
Mount Lebanon in the 1930s

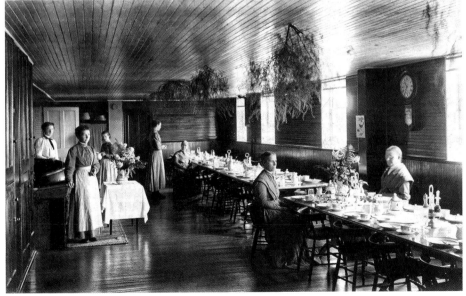

| Plate 155 |

North Family dining room at Mount Lebanon in the 1930s

The Meeting Room

Each family dwelling house had a meeting room. Its purpose was to hold religious meetings two to three times per week, and sometimes talks by an elder or eldress on relevant topics, for instance, news from other communities. After evening chores were done and after a short retirement to their rooms, sisters and brethren would march to the meeting room for worship, dancing, and taking part in spiritual revelations.

A remarkable period from 1837 into the 1850s was known as the Era of Manifestations or Mother Ann's Work. Sisters or brothers, called instruments, would voice messages (gifts), be it text, song, or tunes, imparted to the instruments from departed Shakers or historical figures. The majority of messages gave voice to the traditional Shaker values such as humility, obedience, repentance, and order. Thousands of new songs were sung, especially at Mount Lebanon, as gifts. Whirling, collapsing, shaking, and stomping, the instruments would utter messages from beyond the grave at the gathering in the meeting room or, in some instances, in a meeting house. Today we single out "Simple Gifts," a song whose theme is part of the *Appalachian Spring* suite by Aaron Copland, as an enduring legacy from this era. Artworks also came as gifts; one that survives is *The Tree of Life,* painted by Hannah Cohoon in 1854 at Hancock (see Plate 156). The tree is suggestive of the church: as the tree bears fruit so will the church, extending its branches to all. The spirit texts were written down, copied by scribes, and distributed throughout the Shaker communities. Hundreds of these messages exist today in booklets. By the mid-1850s the revivalist period finally ran its course. Nonetheless, spiritualism still played a role in Shakerism for years to come.

The meeting room at Hancock (see Plate 157) was a pleasant enough room, easily able to handle a hundred or more people. There was nothing pretentious about it. On the other hand, the meeting room in the Church Family's second dwelling house at Mount Lebanon (see Plate 158) seemed very stately. Its floor to ceiling windows, the elaborate curved chairs (no simple benches here; see Plate 159), its built-in organ, and its hanging lamps sharply contrast with the simplicity of the Hancock meeting room or, for that matter, the meeting room of South Family at Mount Lebanon (see Plate 160). The second dwelling house of the Church Family was built in 1875, which may account for its rather ornate furnishings as opposed to Hancock.

THE TREE OF LIFE BY HANNAH COHOON 1854

| Plate 156 |

136

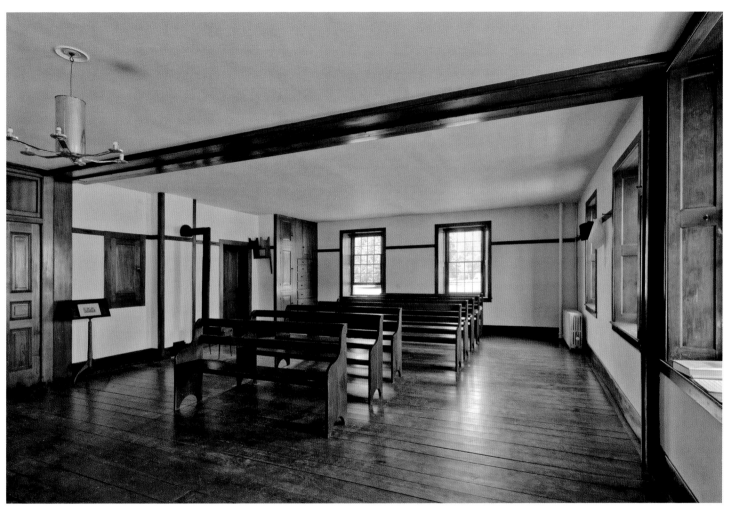

| Plate 157 |

Church Family meeting room at Hancock

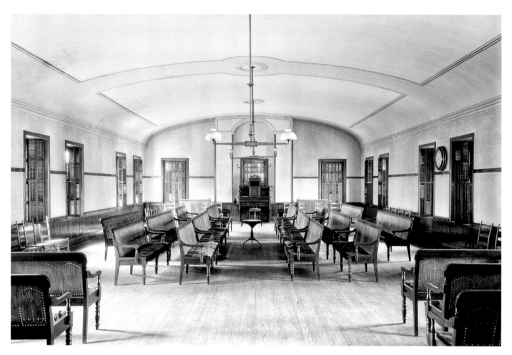

| Plate 158 |

These chairs of the Church Family's meeting room were of plywood and a die tool was used to make the punch-outs. The chairs were made by Gardner & Co. Interestingly, these chairs were found in the attic of the tannery shop at the Hancock Shaker Village.

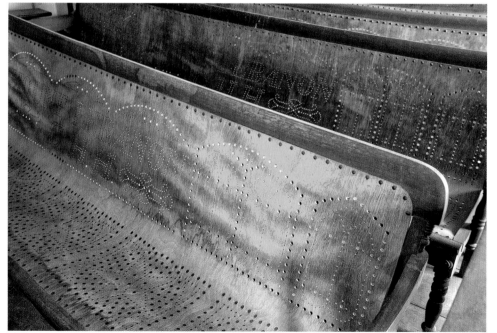

| Plate 159 |

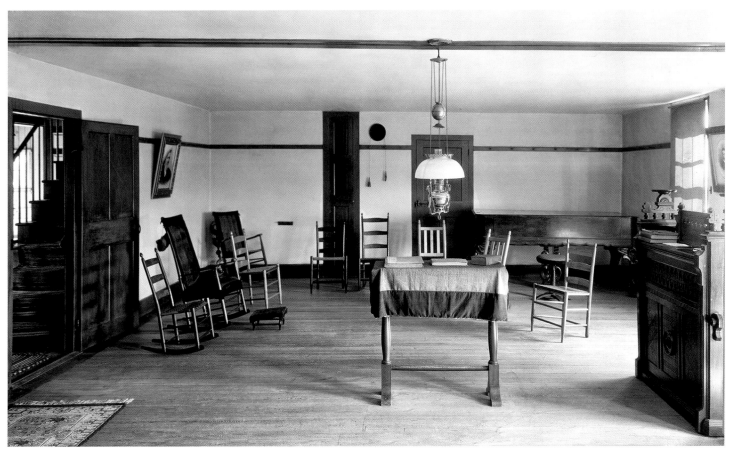

| Plate 160 |

South Family meeting room at Mount Lebanon

Other First Floor Rooms

Several other rooms are also of interest: the visitor's room, the elder's room, and that of the deacon and deaconess. Separation of the sexes outside the dwelling house was impossible due to fact that interactions between the sexes on temporal matters occurred daily. However, when it came to the dwelling house, there were strict rules applied to keep the sexes apart. Brethren entered from an east side entrance, and used their staircase to get to their retiring rooms; sisters used the west entrance and their staircase to get their rooms. Familiarity can breed passion but celibacy was the rule of the day, so internal order was maintained, most of time, via the Millennial Laws and

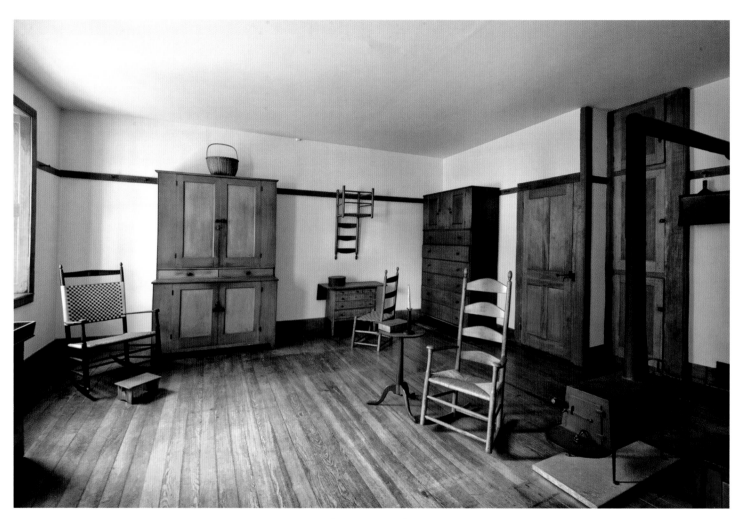

| Plate 161 |
Visitor's waiting room in the dwelling house at Hancock

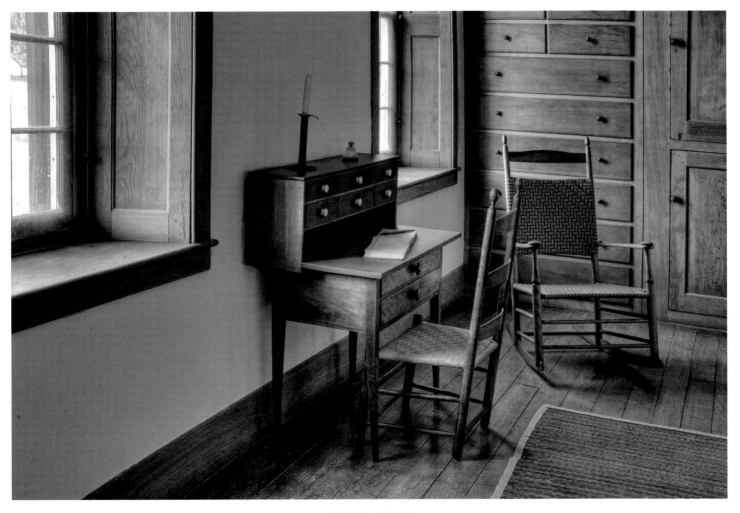

| Plate 162 |

by the brethren and sisters themselves. Even a male visitor had to wait (in the male visitor room; see Plate 161) before being received by a brother; the same held for a female visitor on the west side of the house.

Elders and eldresses had their retiring rooms on the first floor. Plate 162 shows a section of the elder's room with his writing desk. The elder and eldress were the guides to, confessors to, and overseers of their family members in both temporal and spiritual matters. It was they to whom believers went for advice or council.

The deacon and deaconess oversaw the industries of the family, kept the financial accounts, and from time to time conducted business with the outside world. (Plate 163 shows the deacon's room and Plate 165 that of the deaconess.) The

leaders may have been housed on the first floor in order to facilitate accessibility to the believers, and so they could more easily witness the comings and goings within the dwelling house.

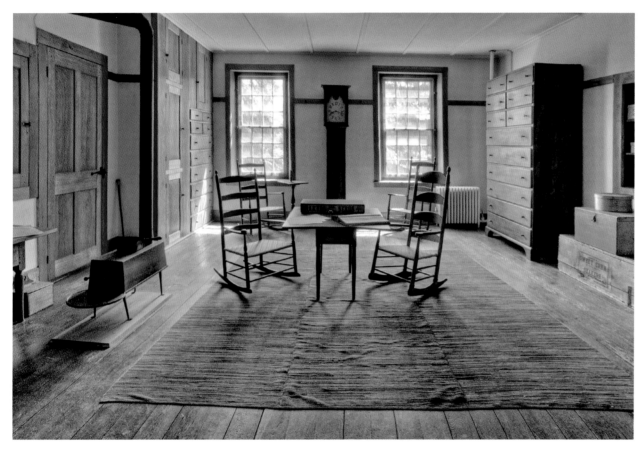

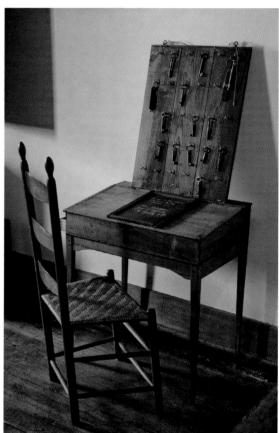

| Plate 163 |
Easily accessible items were stored under lock and key.

| Plate 164 |

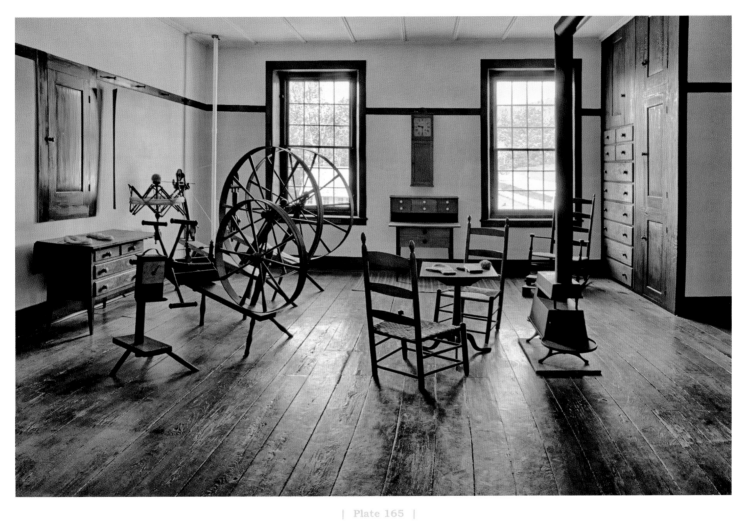

| Plate 165 |

From the 1790s on, a specific facility was used to treat the ill in many communities. In April 1868 the infirmary of the Church Family burned down and wasn't rebuilt, so the dwelling house became the place to service the health of the family members. Hence, a room was set aside as an infirmary for both young and old and as a pharmacy to provide medicines in one form or another. Plate 166 shows the drug dispensary in the infirmary room. Of course, it's small, as there weren't that many drugs in the 1840s. Plates 167 and 168 picture infirmary beds: one for an adult and one for a small child, with a bed warmer for the latter. Mother Ann Lee, the spiritual founder of Shakerism, was biased against physicians and this carried on for some time with the next generation of leaders.

The pharmacy is where herbal medicines were made, dispensed, and records kept (see Plates 169 and 170). Sisters were nurses, and nurse shops or standalone infirmaries were present in villages, as at Canterbury, New Hampshire, and at the Church and South Families at Mount Lebanon.

In the 1850s the Shaker leader Frederick Evans was a proponent of vegetarianism, and won many converts throughout the society. He pushed for a proper diet, good ventilation, proper sanitation, cleanliness, and reduced fat intake, among other things. Sound familiar? However, many, if not all, members still had faith in the healing gift, the laying of the hands to give cure to the ill through a spirit gift and mental control.

Regardless of the method of cure or the lifestyle, statistically the average age at death at two Shaker communities where there were records, Harvard, Massachusetts, and Enfield, New Hampshire, went from early 50s in the 1780s, to 70 or more years of age in the 1890s. For the US as a whole, the average life expectancy was 36.5 and 44 years for the 1780s and 1880s, respectively. These numbers reflect only two Shaker communities; nonetheless, they do show a longer life expectancy among the Shakers than among the general population. These rather large differences are probably due in part to the average age at death for the general population being an average of both infant and adult deaths, whereas the Shakers' average is based on adults only.

| Plate 166 |

144

| Plate 167 |

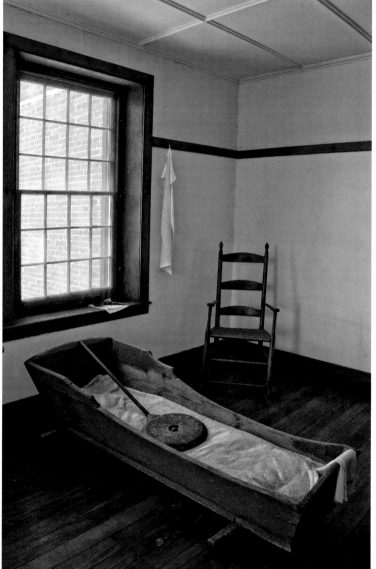

| Plate 168 |

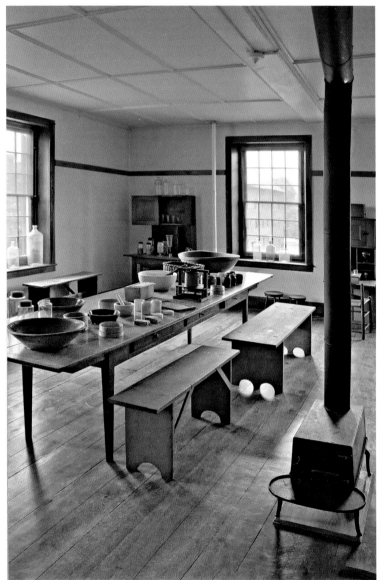

| Plate 169 |

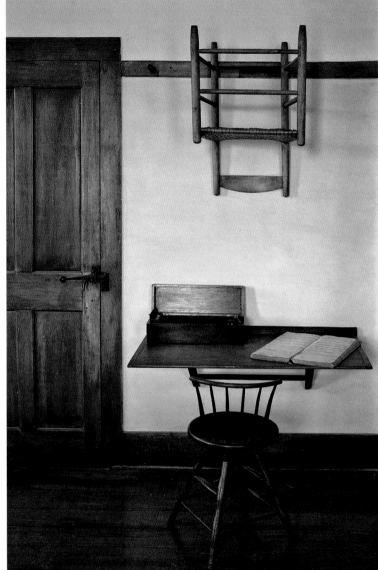

| Plate 170 |

Retiring Rooms and the Union Rooms

Being against superfluity or ornamentation of any kind, the Shakers had strict rules for the furnishings of retiring rooms:

> Bedsteads should be painted green. Blankets or comfortables for outside spreads should be blue and white, but not checked or striped. One rocking chair in a room is sufficient, except where the aged reside. One or two writing tables or desks are permissible. One good looking glass, which ought not to exceed 18 inches in length and 12 inches in width. Window curtains should be white, or a blue or a green shade, or some very modest color, and not red, checked, or striped or flowered. No maps, charts and no pictures or paintings, shall be hung up in your dwellings, shops, or office. And no pictures or paintings set in frames, with glass before them shall ever be among you. An elegant but plain stove; two lamps, one candle stick, and a smoker or tin funnel to convey to the chimney the smoke and gas evolved from the lights.[21]

Anywhere from two to eight individuals would occupy a retiring room, which contained furnishings following such rules (see Plate 171). Stained floors were allowed by the orders if they were reddish-yellow or yellow in color (see Plates 172 and 173).

The children's rooms were similar to those of sisters or brethren but with fewer furnishings. Plates 174 and 175 depict a child's retiring room with a small bed, privy, and wash basin. From 1800 to about 1870, when they were taking in children and then caring for them, each village had a children's dwelling house. But as the number of children became small in number, they were shifted to the family dwelling house. This was true at Hancock as well as other villages.

There definitely was a lack of privacy among Shaker sisters and brethren, and for good reason: to keep members from crossing the celibacy line. Such factors as equality of sexes, separation of sexes, and obedience to celibacy must have created a certain amount of sexual tension among the believers. Yet the dividing line was held for the most part.

There were always going to be daily interactions between the sexes on temporal matters. It was unavoidable. So, Joseph Meacham, a second generation leader, figured if they had a spiritual union, it would lessen greatly the potential of a physical, or carnal, union. Hence, he instituted the union meeting.

A group of four to ten members of each sex would meet two days a week and on the Sabbath in a brother's room. They sat in tilted-back chairs, facing each other, then for one hour each member would, in turn, converse with his/her opposite (see Plate 176). Usually the elders selected the pair based on compatibility, which focused mostly on age. Talk was facetious most of the time rather than profound and was reasonably unrestrained and joyful. There were times when they just sang. The degree of decorum and sobriety of union meetings differed from community to community and family to family, but members never castigated or had negative comments about their fellow believers. It was a Shaker rule: if you don't have something nice to say about someone, then don't say anything at all. Union meetings played an important role in the community life of the Shakers.

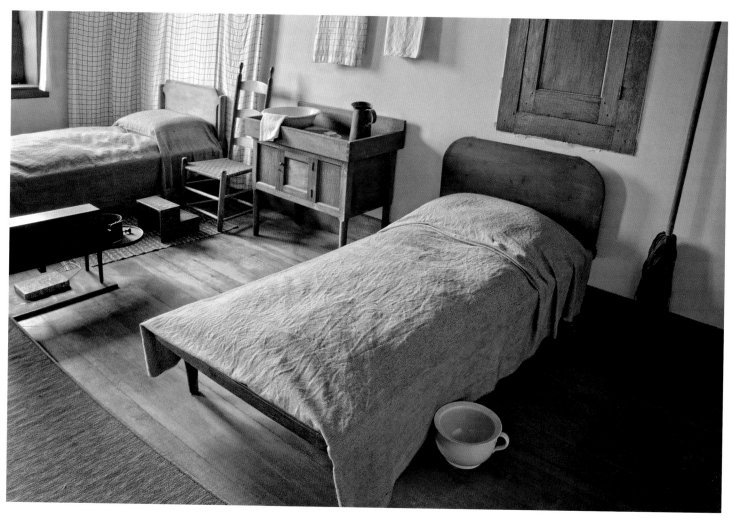

| Plate 171 |

148

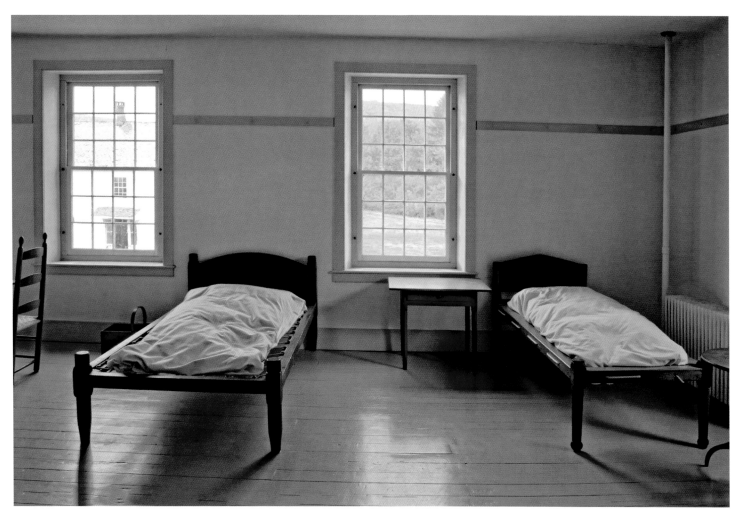

| Plate 172 |

149

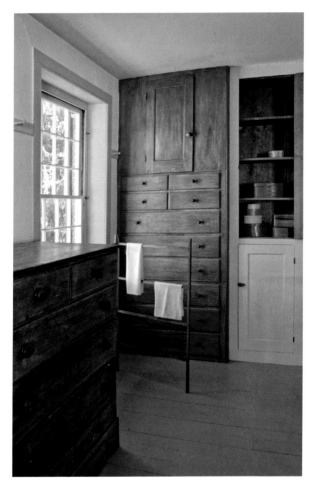

| Plate 173 |

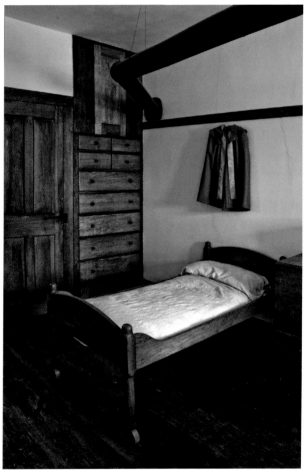

| Plate 174 |
Child's room in the Hancock dwelling house

| Plate 175 |

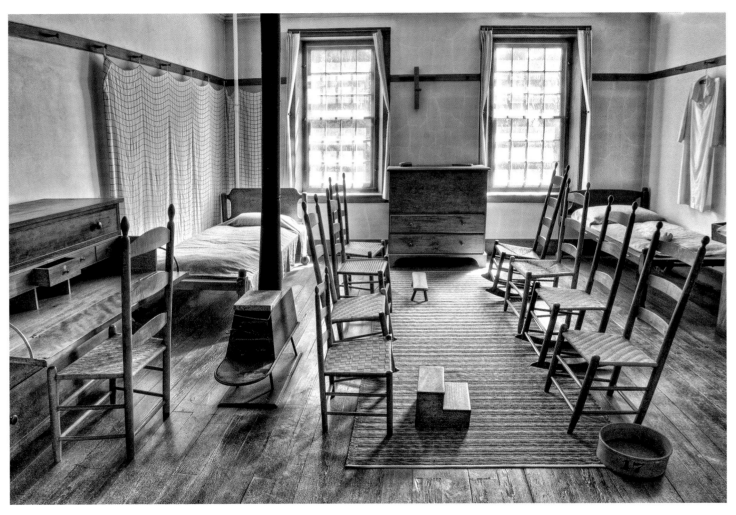

| Plate 176 |
Brethren's union meeting room

The sectarian attitude of divorcing itself from the world began to change for the United Society of Believers in the Christ's Second Appearing, the Shakers. After 1876, there was a definite change in the attitude among a progress group within the society who wanted to try to change things for the better in the world, by engaging the world. Voices from the North Family at Mount Lebanon led the way. Frederick W. Evans, Mary Antoinette Doolittle, and Catherine Allen were among the strongest for advocating intercourse with the world to make it a better place through the legacy of the Shakers. Hancock elders, on the other hand, were silent during this period with little or no voice in worldly matters. Voices for reconciliation with the world and pluralism among the society members would mark the next thirty-five years, from 1875 to 1910.

For every sociopolitical action there is bound to be an opposing reaction. It came in the form of conservative voices of the society, such as Henry Blinn of Canterbury, New Hampshire, Giles Avery of Mount Lebanon, and Hervey Ads of the South Union community in Ohio. They sought to return to testimonies of Mother Ann and others to bolster the declining membership, but the world heard and recognized the progressive voices more than the conservative ones.

Frederick W. Evans was the de facto voice of the Shakers to the world from about 1868 to 1885 (see Plate 177). He was an elder at Mount Lebanon, and an excellent writer and lecturer. He entertained the likes of Charles Nordhoff, the historian, and corresponded with Leo Tolstoy to explain Shakerism. He was a crusader on many fronts. Some of his efforts were for the abolition of wage slavery, and against imprisonment for debt; he supported equal rights for women, advocated public schools for everyone to age twenty-one, was anti-tobacco, and was against any union of church and state. The latter position reveals an interesting aspect of the man's character. He warned of serious consequences if civil and ecclesiastical forces were joined together—he knew his history. Most of the pro and con positions taken by Evans were those accepted by many, but not all, Shakers. In the last quarter of the nineteenth century, the acceptance by Shakers of decorating with flowers, hanging of pictures, reading of newspapers and books on travel, science, and history, playing organ music, and attending reading and debating meetings all pointed to this reconciliation with the world as espoused by Evans.

Mary Antoinette Doolittle (see Plate 178), usually called Antoinette Doolittle, joined the Shakers at age fourteen against her parents'

| Plate 177 |
Frederick W. Evans (1810–1893)

wishes. The year was 1824. It says something about Antoinette—she was strong willed. She was an outspoken critic of a governmental system that precluded women from the governing institutions, the legislative halls. When she was

in 1873 from *The Shaker* to *The Shaker and Shakeress.* In 1876 the former editor, George Lomas, returned and the former name, *The Shaker,* was again adopted. Then in 1879 it was renamed *The Shaker Manifesto,* the name it kept until December 1899, the closing month and year for the publication.

Doolittle's motto was "Truth contains no mystery." She abided by that motto when writing for the Shakers' journal. She was a prolific writer and set the literary standard for the sisters contributing to it. She gave an avenue of expression for the Shaker sisterhood that lasted for many years.

Due to the influence of Frederick Evans, the North Family at Mount Lebanon remained the progressive arm of the society at the end of the nineteenth century and the beginning of the twentieth. Catherine Allen (see Plate 179) became the spokesperson for the North Family and served on the central ministry until her death in 1922.

No one was more committed to progressive change than Catherine. She was dogged. Nothing but radical social and political change would be acceptable to her, including getting rid of business monopolies, establishing universal suffrage for women, abolishing usury, establishing compulsory education, taxing all church properties, abolishing capital punishment, and establishing government ownership of utilities and communications, to name a few. In 1905, with her help, an international peace convention was held at Mount Lebanon. Its resolutions dealt with pleas for international arbitration of disputes between parties, reduction in armaments, and boosting

the judicial power of the Hague court. These were far-sighted resolutions by a group of people who had been largely cut off from world affairs for over one hundred years.

If anything might be said about Catherine Allen, it would be that she was a visionary, very much concerned with making this world a better place and the people in it better through education. In 1891 she started the Self-Improvement Society at Mount Lebanon to teach the sisters to appreciate beautiful things,

an eldress at the North Family at Mount Lebanon, it's no surprise that Evans made her coeditor of *The Shaker,* the society's journal/newsletter, to deal with women's issues and opinions while he handled the male side. Antoinette encouraged the sisterhood to contribute their opinions, which struck a chord; essays, poems, and opinions on many topics poured in. *The Shaker* became a voice for the sisters throughout all communities. The enthusiastic response by women may have triggered the name change

and to read and discuss what they read on various subject matters in order to expand their intellectual horizons. This was a radical departure from traditional Shaker practices in education.

She saw the problems of the world in its love of greed, its oppression by corporations, the free enterprise system, and the unjust financial system. Her vision for a better world was based on traditional Shaker concepts; their legacy was to share the natural wealth with everyone, equalize educational opportunities for all, replace competition with cooperation, ensure labor-saving devices should be a relief, not a burden, on labor, and vastly improve our dietary habits. It is interesting to realize that the problems facing twenty-first-century people are still the same problems of the past as spelled out by Allen. Yes, she was a visionary looking for solutions to world problems. She was a modern-day Shaker who promoted the Shaker legacy.

There was another voice of the Shakers, a business and financial voice, embodied in Ira Lawson, who came to and joined the Hancock Shakers in the year 1851 at age eighteen. For the next eleven years he was farm manager at the West Family, where his business acumen was recognized. He was made second elder at the West Family, then in 1862 was reassigned to the Church Family and became one of the trustees. The Church Family was in a financial debt crisis, somewhere around $2,000, at the time of his appointment. Through his shrewd business dealings and entrepreneurial drive, he managed, over the next forty or so years, to create $200,000 in assets for the Hancock Shakers in the forms of low-risk securities, valuable lands, mills, and buildings by the time of his death in April 1905 at age 71 from complications brought on by pneumonia.

| Plate 180 |
Ira R. Lawson (1834–1905)

In the years between 1862 to 1900, Ira Lawson invested $75,000 in updating buildings, grounds, and equipment. He updated the trustee's office, built a new icehouse, updated the grist and lumber mills, and secured depot buildings at Boston and Albany Railroad. Many of these latter investment activities brought money into the Hancock Shaker community over time. He was appointed to the Central Ministry in May 1899 to oversee the selling off of Shaker lands and the closure and sale of some communities. His business insight and judgment were invaluable, and Lawson's efforts very likely forestalled closure of Hancock for many decades.

BIBLIOGRAPHY

Andrews, Edward Deming. *The People Called the Shakers.* New York: Dover, 1963.

Andrews, Edward Deming and Faith Andrews. *Fruits of the Shaker Tree of Life.* Stockbridge, MA: Berkshire Traveller Press, 1975.

Andrews, Edward Deming and Faith Andrews. *Shaker Furniture.* New York: Dover, 1964.

Andrews, Edward Deming and Faith Andrews. *Work and Worship Among the Shakers.* New York: Dover, 1974.

Bial, Raymond. *The Shaker Village.* Lexington, KY: University Press of Kentucky, 2008.

Elkins, Hervey. *Fifteen Years in the Senior Order of Shakers: A Narration of the Facts Concerning That Singular People.* Hanover, NH: Dartmouth Press, 1853.

Emlen, Robert P. *Shaker Village Views.* Hanover, NH: University Press of New England, 1987.

Goodwillie, Christian and John H. Ott. *Hancock Shakers Village: A Guidebook and History.* Hancock, MA: Hancock Shaker Village, 2011.

Lassiter, William L. *Shaker Architecture.* New York: Bonanza Books, 1966.

Miller, Amy Bess. *Hancock Shaker Village/The City of Peace.* Hancock, MA: Hancock Shaker Village, 1984.

Miller, M. Stephen. *From Shaker Lands and Shaker Hands.* Hanover, NH: University Press of New England, 2007.

Morse, Flo. *The Shaker Story.* Woodstock, VT: The Countryman Press, 1986.

Riesman, Timothy D. *Shaker, The Art of Craftsmanship: The Mount Lebanon Collection.* Alexandria, VA: Art Services International, 1995.

Stein, Stephen J. *The Shaker Experience in America.* New Haven, CT: Yale University Press, 1992.

NOTES

1. Edward Deming Andrews, *The People Called the Shakers* (New York: Dover, 1963), 55.
2. Ibid., 59.
3. Ibid., 24.
4. Ibid., 60.
5. Ibid., 60.
6. Ibid., 61.
7. Ibid., 126.
8. Edward and Faith Andrews, *Work and Worship Among the Shakers* (New York: Dover, 1974), 63.
9. Edward Deming Andrews, *The People Called the Shakers* (New York: Dover, 1963), 119.
10. Hervey Elkins, *Fifteen Years in the Senior Order of Shakers: A Narration of the Facts Concerning That Singular People* (Hanover, NH: Dartmouth Press, 1853), 13, 15.
11. Image #16, *The Shaker Manifesto, 1871 to 1899,* 29:12 (Dec. 1899). Hamilton College Digital Collection.
12. Flo Morse, *The Story of the Shakers* (Woodstock, VT: The Countryman Press, 1986), 58.
13. Amy Bess Miller, *Hancock Shaker Village/The City of Peace* (Hancock, MA: Hancock Shaker Village, 1984), 43.
14. Image #4, *The Shaker Manifesto, 1871 to 1899,* 5:3 (Mar. 1875). Hamilton College Digital Collection.
15. Edward Deming Andrews, *The People Called the Shakers* (New York: Dover, 1963), 280.
16. Amy Bess Miller, *Hancock Shaker Village/The City of Peace* (Hancock, MA: Hancock Shaker Village, 1984), 95.
17. Stephen J. Stein, *The Shaker Experience in America* (New Haven: Yale Univ. Press, 1992), 341.
18. Edward Deming Andrews, *The People Called the Shakers* (New York: Dover, 1963), 257.
19. Ibid., 283.
20. Ibid., 148.
21. Ibid., 273.

INDEX OF PLATES

PHOTOGRAPHERS				LOCATION	
C.C.A.	C. C. Adams	J.R.V.	Joseph R. Votano	ML	Mount Lebanon
J.E.B.	Jack E. Boucher	N.E.B.	N. E. Baldwin		
J.I.	James Irving	R.L.	Robert Lamacq		
J.E.W.	J. E. West	W.F.W. Jr.	William F. Winters, Jr.		

PLATE NO.	DESCRIPTION	PHOTOGRAPHER	LIBRARY
1	1820 Map Hancock Village	NA	
2	1939 Map Mount Lebanon	NA	US Congressional
3	Hancock	J.R.V.	
4	Hancock	J.R.V.	
5	Seed Packing Room at North Family ML	C.C.A.	US Congressional
6	Seed Instruction Label, Peas	NA	Hamilton College
7	Seed Instruction Label, Tomato	NA	Hamilton College
8	Vegetable Garden Hancock	J.R.V.	
9	Garden Hancock, Infrared Image	J.R.V.	
10	Vacuum Extractor 1920s	W.F.W. Jr.	US Congressional
11	Herbal Factory Center Family ML 1930	W.F.W. Jr.	US Congressional
12	Poster	NA	Hamilton College
13	Label	NA	Hamilton College
14	Label	NA	Hamilton College
15	Label	NA	Winterthur
16	Chair Ad	NA	US Congressional
17	Chair factory at South Family at ML 1930	W.F.W. Jr.	US Congressional
18	Chair factory at South Family at ML	J.R.V.	
19	Sisters' Chair Factory South Family ML 1920s	W.F.W. Jr.	US Congressional
20	Label	NA	Hamilton College
21	Second Family Chair Factory ML 1938	N.E.B.	US Congressional
22	Sarah Collins Seating a Chair	Unkn	Winterthur
23	Chair Hancock	J.R.V.	
24	Waiting Room Hancock Dwelling House	J.R.V.	
25	Chair	J.R.V.	
26	Receipt for Shaker Chairs	NA	Hamilton College
27	South Family Show Room 1930s	W.F.W. Jr.	US Congressional
28	Hancock Dwelling House	J.R.V.	

NA = Not applicable
Unkn = Unknown

PLATE NO.	DESCRIPTION	PHOTOGRAPHER	LIBRARY
29	Brethren Shop Hancock	J.R.V.	
30	Laundry and Machine Shop Hancock	J.R.V.	
31	Hancock Dwelling House	J.R.V.	
32	Brushes	Unkn	
33	Damon Swift	J.R.V.	
34	Cloak	J.R.V.	
35	Cloak	J.R.V.	
36	Cloak Making Hancock	J.R.V.	
37	Poster	NA	
38	Cloak Making at Mount Lebanon	Unkn	Hamilton College
39	Cotton Net Caps	W.F.W. Jr.	Winterthur
40	Silk Bonnet	J.R.V.	
41	Box Mold	J.R.V.	
42	Oval Nested Boxes	J.R.V.	
43	Carrier Box	J.R.V.	
44	Hancock Map	NA	Hancock
45	Round Stone Barn	Unkn	Winterthur
46	Early Morning at Hancock	J.R.V.	
47	Early Morning at Hancock	J.R.V.	
48	Early Morning at Hancock	J.R.V.	
49	Early Morning at Hancock	J.R.V.	
50	Early Morning at Hancock	J.R.V.	
51	Early Morning at Hancock	J.R.V.	
52	Blacksmith at Hancock	J.R.V.	
53	Blacksmith at Hancock	J.R.V.	
54	Schematic Blacksmith Shop North Family ML	NA	US Congressional
55	Blacksmith Shop at North Family at ML	Unkn	Winterthur
56	Blacksmith Shop at North Family at ML	W.F.W. Jr.	US Congressional
57	Tannery Hancock	J.R.V.	
58	Tannery Mount Lebanon	J.R.V.	
59	Tannery Door Hancock	J.R.V.	
60	Peg Threader	J.R.V.	
61	Wooden Vise	J.R.V.	
62	Shoe Shop	J.R.V.	
63	Shoe Shop	J.R.V.	
64	Shoe Repair Pedestal	J.R.V.	
65	Brethren's Shop Hancock	J.R.V.	
66	Brethren's Shop Mount Lebanon	J.R.V.	
67	Three and Four Slatted Chairs	J.R.V.	
68	Chair Making Hancock	J.R.V.	
69	Brethren's Workshop	J.R.V.	

NA = Not applicable

Unkn = Unknown

PLATE NO.	DESCRIPTION	PHOTOGRAPHER	LIBRARY
70	Church Family Brethren's Workshop ML 1920s	W.F.W. Jr.	US Congressional
71	Sisters' Dairy and Weave Shop Hancock	J.R.V.	
72	Sisters' Dairy and Weave Shop Hancock	J.R.V.	
73	Sisters' Dairy and Weave Shop Hancock	J.R.V.	
74	Sisters' Weaving Room Hancock	J.R.V.	
75	Looms at North Family Mount Lebanon 1930	W.F.W. Jr.	US Congressional
76	Weaving looms at the Sisters' Dairy and Weave Shop	J.R.V.	
77	Laundry and Machine Shop Hancock	J.R.V.	
78	Laundry and Machine Shop Hancock	J.R.V.	
79	Laundry and Machine Shop Hancock 1931	W.F.W. Jr.	US Congressional
80	Laundry and Machine Shop Hancock	J.R.V.	
81	Laundry and Machine Shop Hancock	J.R.V.	
82	Laundry and Machine Shop Hancock	J.R.V.	
83	Ironing Room at Laundry and Machine Shop Hancock 1931	W.F.W. Jr.	US Congressional
84	Drying Racks North Family Wash-house ML	J.R.V.	
85	Ironing Room North Family ML	Unkn	Hamilton College
86	Laundry Press North Family ML 1938	N.E.B.	US Congressional
87	Laundry and Machine Shop Hancock	J.R.V.	
88	Laundry and Machine Shop Hancock	J.R.V.	
89	Ministry Workshop Hancock	J.R.V.	
90	Ministry Workshop Mount Lebanon	J.R.V.	
91	Ministry Living Quarters Hancock	J.R.V.	
92	Ministry Wash House Hancock	J.R.V.	
93	Ministry Office		J.R.V.
94	Ministerial Workshop Hancock	J.R.V.	
95	Schoolhouse Hancock	J.R.V.	
96	Schoolhouse Hancock	J.R.V.	
97	Schoolhouse Hancock	J.R.V.	
98	Schoolhouse Hancock	J.R.V.	
99	Classroom, Room 19 Dwelling House Hancock	J.E.B.	US Congressional
100	Classroom Mount Lebanon	J.I.	US Congressional
101	Round Stone Barn	J.R.V.	
102	Round Stone Barn	J.R.V.	
103	Interior Round Stone Barn	R.L.	
104	Round Stone Barn	J.R.V.	
105	Interior Round Stone Barn	J.R.V.	
106	Doorway Round Stone Barn	J.R.V.	
107	North Family Great Barn ML	Unkn	Winterthur
108	Schematic of Great Barn at ML	NA	US Congressional
109	Barn at Hancock	J.R.V.	

NA = Not applicable

Unkn = Unknown

PLATE NO.	DESCRIPTION	PHOTOGRAPHER	LIBRARY
110	Barn at Hancock	J.R.V.	
111	Silos at Hancock	J.R.V.	
112	Hired Men's Shop Hancock	J.R.V.	
113	Hired Men's Shop Hancock	J.R.V.	
114	Hired Men's Shop Hancock	J.R.V.	
115	Hired Men's Shop Hancock	R.L.	
116	Poultry House Hancock	J.R.V.	
117	Icehouse Hancock	J.R.V.	
118	Destroyed Sisters' Workshop Second family ML	Unkn	US Congressional
119	Barn Fire Mount Lebanon 1912	Unkn	US Congressional
120	Great Barn at Mount Lebanon	J.R.V.	
121	Cemetery Hancock	J.R.V.	
122	Cemetery Hancock	Unkn	Winterthur
123	Grave Markers Hancock	J.R.V.	
124	Shaker Store Hancock	Unkn	US Congressional
125	Shaker Store Hancock	Unkn	US Congressional
126	Trustee's Office and Store Hancock	J.R.V.	
127	Trustee's Office and Store Church Family ML 1938	N.E.B.	US Congressional
128	Parlor Trustee's Office Hancock	J.R.V.	
129	Store at Hancock	R.L.	
130	Store at Hancock	R.L.	
131	Record and Cashier's Office	R.L.	
132	Meeting House Hancock	J.R.V.	
133	Meeting House Interior Hancock	J.R.V.	
134	1871 Renovated Meeting House Hancock	Unkn	Winterthur
135	Second Meeting House Mount Lebanon	J.R.V.	
136	Interior Second Meeting House ML	Unkn	US Congressional
137	Schematic of Meeting House ML	NA	US Congressional
138	Schematic of Meeting House ML	NA	US Congressional
139	Benches Meeting House ML	Unkn	Winterthur
140	Drawing	NA	
141	Dwelling House Enfield, NH	J.R.V.	
142	Second Dwelling House Church Family ML	J.R.V.	
143	Dwelling House Canterbury, NH	J.R.V.	
144	Dwelling House Hancock	J.R.V.	
145	Kitchen Dwelling House Hancock	J.R.V.	
146	Ovens Kitchen Hancock 1939	N.E.B.	US Congressional
147	Kitchen Dwelling House Hancock	J.R.V.	
148	Kitchen Dwelling House Hancock	J.R.V.	
149	Storage Rooms, Kitchen Hancock	J.R.V.	

NA = Not applicable
Unkn = Unknown

PLATE NO.	DESCRIPTION	PHOTOGRAPHER	LIBRARY
150	Kitchen North Family Mount Lebanon	J.E.W.	Winterthur
151	Dining Room Dwelling House Hancock	J.R.V.	
152	Ministry's Dining Room Hancock	J.R.V.	
153	Dining Room Dwelling House Hancock 1931	W.F.W. Jr.	US Congressional
154	Dining Room Church Family ML	Unkn	US Congressional
155	Dining Room North Family ML	J.E.W.	Winterthur
156	Tree of Life Drawing by Hannah Cohoon		Hancock Collection
157	Meeting Room in Dwelling House at Hancock	J.R.V.	
158	Meeting Room in Church Dwelling House at ML	W.F.W. Jr.	US Congressional
159	Fancy Meeting Room Chairs	J.R.V.	
160	South Family Meeting Room at ML	W.F.W. Jr.	US Congressional
161	Visitor's Waiting Room Hancock	J.R.V.	
162	Elder's Room in Dwelling House Hancock	J.R.V.	
163	Deacon's Room in Dwelling House Hancock	J.R.V.	
164	Deacon's Room in Dwelling House Hancock	J.R.V.	
165	Deaconess's Room in Dwelling House Hancock	J.R.V.	
166	Pharmacy's Closet Dwelling House Hancock	J.R.V.	
167	Infirmary Room Dwelling House Hancock	J.R.V.	
168	Infirmary Room Dwelling House Hancock	J.R.V.	
169	Pharmacy in Dwelling House Hancock	J.R.V.	
170	Pharmacy in Dwelling House Hancock	J.R.V.	
171	Retiring Room in Dwelling House Hancock	J.R.V.	
172	Retiring Room in Dwelling House Hancock	J.R.V.	
173	Retiring Room in Dwelling House Hancock	J.R.V.	
174	Children's Retiring Room in Dwelling House Hancock	J.R.V.	
175	Children's Retiring Room in Dwelling House Hancock	J.R.V.	
176	Union Meeting in Brethren's Room Hancock	J.R.V.	
177	Frederick W. Evans	Unkn	Hamilton College
178	Mary Antoinette Doolittle	Unkn	Winterthur
179	Catherine Allen	Unkn	Winterthur
180	Ira R. Lawson	Unkn	Hamilton College

NA = Not applicable
Unkn = Unknown

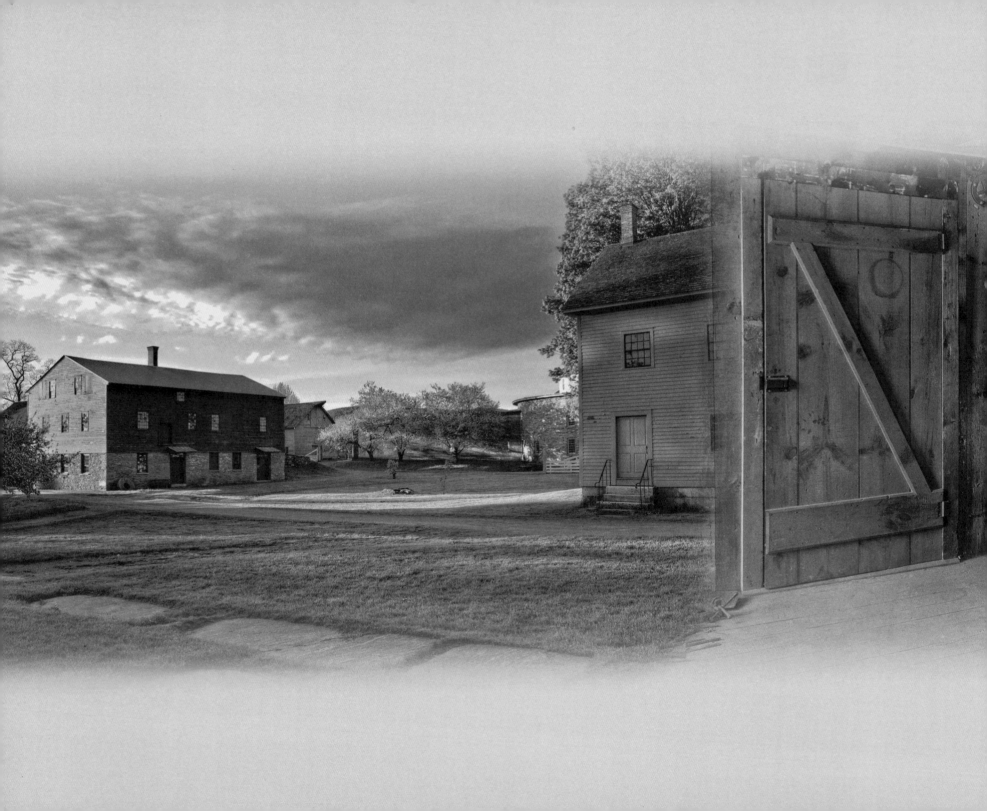